D1323390

The Crab Orchard Chronicals

FUNNY STORIES FROM THE HILLS OF THE EAST TENNESSEE

BY

JIMMIE TURNER

Copyright © 2024 by Jimmie Turner

All rights reserved. No part of this publication may be re-produced, distributed, or transmitted in any form or by any means, including photocopying, recording, or publisher, except in the case of brief quotations embodied in critical reviews and certain other noncommercial uses permitted by copyright law.

Published by: Book Writing Pioneer

DEDICATION

In heartfelt dedication to my beloved wife, Morine, of 59 remarkable years. Her unwavering support has been my anchor through the highs and lows, the joys, and the challenges. Together, we've been blessed with four incredible children, each with their own beautiful families, all embracing the path of born-again Christians. Among them is our son Johnathan, who now pastors in Oliver Springs, Tennessee, thriving in his endeavors. With immense gratitude, we thank the divine for the many blessings and grace bestowed upon us throughout these cherished years.

ABOUT THE AUTHOR

Embracing a life dedicated to the Lord and being born again hasn't robbed me of my sense of humor. Over the years, God has used me as an instrument of joy for many. An unexpected opportunity arose during my time working at the Tennessee State youth camp. While sharing amusing tales with fellow pastors during a break in the cafeteria, Sister Wonniw Weakley, the wife of our state bishop, overheard. Impressed, she invited me to entertain at the State Minister's Banquet. Despite having no plan initially, I crafted humorous songs and stories about pastor friends. To my surprise, the performance at the banquet, attended by around 400 people, was a hit, leading to invitations for fun programs at Marriage Retreats, Men's Retreats, Bible Schools, and various church events. Notably, I even declined a job offer to perform at a night club, emphasizing my commitment to clean humor. Born and raised around the Crab Orchard & Crossville, Tennessee area, my wife and I have served as pastors for 47 years. I sincerely hope this little book brings you joy and blessings.

TABLE OF CONTENT

INTRODUCTION
CRAB ORCHARD, TENNESSEE

Crab Orchard is a small town in Cumberland County, Tennessee, with a population of about 750. It is located right next to the great Crab Orchard Mountains. The town gets its name from the many thousands of crabapple trees that grow all around it in the hills and hollers. The town is positioned in a gap in the mountains, which became an early gateway to the Cumberland Plateau area. In the 1780s, a road was built in the gap to provide protection for travelers migrating to the Nashville area.

Crab Orchard has given its name to a rare type of durable sandstone found in its vicinity, which was first used in structures and sidewalks in the late 19th century. Crab Orchard Stone gained popularity in the 1920s when it was used in the construction of Scarritt College in Nashville. It is now quarried in many different areas of the county and is shipped all over the United States and the world.

Some of the finest and funniest people in the world come from Crab Orchard, and many of them could be professional comedians, often funnier than many of those on TV. They can tell you a funny story in the blink of an eye, and at first, you will think it is true until they get to the punchline.

One day, I was telling a preacher friend of mine about Crab Orchard, and he said, 'You should write a book and call it The Crab Orchard Chronicle.' So, over the years, I thought about it and decided to go ahead and do it.

Crab Orchard does have some claims to fame, such as the CMT sitcom, 'I-40 Paradise,' with its setting here. Some notable folks from Crab Orchard include the world-famous weather forecaster Helen Lane, professional Major League Baseball player Neal Holliway, well-known minister of the gospel VR Sherrill, who established twenty

churches in the state of Pennsylvania, and Jimmie Ellis, who has been a pastor with the Church of God of Prophecy and was born in Crab Orchard. I myself was born on the Lavern Wheeler farm and raised in the Crab Orchard and Crossville area for many years.

This little book was not written with the intention to put anybody down or to make fun of anyone, but it was written to bring laughter to people, and I hope it is read with that in mind. After all, the Bible does say in Proverbs 17:22, 'A merry heart doeth good like a medicine, but a broken spirit drieth the bones.'

INTRODUCTION

I was born in Crab Orchard, Tennessee, on the LeVern Wheeler Farm, which is now at the junction of Interstate 40 and Bat Town Road. I was raised in and around the Crab Orchard and Crossville area. Later in life, as I grew up and got married, my wife Morine and I found salvation, and I was called to preach the Gospel of Jesus Christ.

While pastoring in the great state of Pennsylvania, we met and got to know another pastor and his wife. The pastor, whose name was Jim Ellis, was actually born and raised in the Crab Orchard area. Many times, our families would get together and go places, having picnics and engaging in other activities. Jim and I would often share funny stories from our childhood days growing up in Crab Orchard.

One day, Jim suggested, 'You ought to write a book about Crab Orchard and call it "THE CRAB ORCHARD CHRONICLES."' Over the years, I thought about it and finally started putting some stories together, which allowed me to write this little book.

Some of the stories in this book are true and involve me, while others involve my friends. Some are simply tales I've heard. Not all the stories in this book have punchlines; some are amusing anecdotes of things that really happened, like 'Surgery in Daddy's Creek' and 'The Boys Skiing down the Mountain.'

One thing is certain: This little book was in no way written to make fun of anybody or to look down on hillbilly folks because that's what I am. Instead, it is written to bring a little laughter to a troubled world. The Bible says in Proverbs 17:22, 'A merry heart doeth good like a medicine, but a broken spirit drieth the bones.'

SOME FUNNY SAYINGS

IF ANY OF THE SAYINGS WRITTEN BELOW ARE SOME-
THING YOU MIGHT DO OR SAY, YOU JUST MIGHT BE
FROM CRAB ORCHARD, TENNESSEE:

- Be thankful that your momma had ammo on her Christmas list for you.

- Give thanks for your Christmas gift of a painting on sheetrock.

- Sign your neighbor's petition to get your Christmas lights taken down.

- Your wife tells you, 'Get that motor out of my tub so I can take a bath.'

- You siphon gas out of your lawnmower to put in your truck.

- You take your buddies down to Daddy's Creek to prove you can drown a fish.

- You knock the spider web down so you can get into your bathroom.

- You have another can of your favorite meat, Spam.

- You put on a big barbecue roast for all your friends and neighbors, featuring Spam.

- You send a request to a major fragrance designer to try to recreate the smell of a dead skunk.

- You appreciate your wife howling at the moon more than your hunting dogs.

- You have your kids fight with your dogs for their dinner.

- You go to the store to try to find some FRANKLIN MINT breath fresheners.

- You buy a can of Pepsi to cut the top out of it to use to spit tobacco juice into.

- You practice doctoring with mama's sewing kit and a jug of moonshine.

- You make a bumper sticker that says, 'My mamma's an honor student at the local junior high.'

- You stand in line to have your picture taken with a freak of nature.

- You have to vacuum your sheets instead of washing them due to the bread crumbs and crackers.
- You bake one of your favorite meals in the oven: potted meat on saltines.

- You drive down to Cookeville to try to find the stock market with a fence around it.

- You plant your spring flowers in the front yard in a commode.

- You try to find an empty telephone wire spool for a coffee table.

- You watch the Academy Awards to see if 'Smokey and the Bandit' won.

- You supplement your major food groups with beef jerky and Moon Pies.

- You thank your father for encouraging you to quit school.

- You're successful because you have two cars up on blocks."

ADVERTISEMENT IN LOCAL PAPER

Join us for a big Square Dance, Pie Supper, Cakewalk, and Bake Sale next Saturday night at the Browntown High School Gymnasium, starting at 6:30 PM. The gymnasium is located in downtown Browntown, Tennessee, right across the street from Cousin Al's Service Station and Junkyard.

Tony Brown and his Downtown Browntown Brown Bears will be the host entertainers, and the guest stars will be Roadhog Marone and his world-famous Silverado Playboys, who will be calling the square dance. Bring your girlfriend, wife, or husband and dance the night away.

Admission at the door will be $3.50 if you have the label from at least a five-pound bag of Martha White Self-Rising Flour, and $3.75 if you don't. All proceeds will go toward supporting Tony Brown and his Beloved Brown Bears so they can embark on a Countywide Tour.

FLUTER'S FIRST LOVE

Flutter Ivey told me he met his first love at church in Crab Orchard. He said, 'I would sit on the back pew, and she would sit on the front. She would turn around and cock one eye at me, and I would cock one at her, so there we would sit, looking cockeyed at one another. Boy, was she a beauty: She had beautiful golden hair running down her back, none on her head. She had two beautiful blue eyes always looking at one another. When she would cry, tears would run down her back; the doctors called it 'bacteria.' She could stand on her front porch and count her chickens in the backyard.

I went over to her house one day to take her to get an ice cream. I pulled up in front of the house and hollered, 'Honey, come on out here.' She replied, 'I can't right now, I'm taking a bath.' I said, 'Oh, slip on something and come on out,' so she did. She slipped on a bar of soap, and there she was. Well, I took her to Mitchell's Drug Store and bought her an ice cream cone. She ate the ice cream off the cone and then handed the cone back in and said, 'Here, mister, here's your funnel.'

I drove out to her house one day, and her dad told me to come in. He said, 'I want to show you this chair that goes all the way back to Louis the 14th.' I told him, 'If you'll come over to the house, I'll show you this washer & dryer that goes back to Sears the 15th.' Well, this trucker stole her from me, and they eloped to Ringgold, Georgia, and got married by the Justice of the Peace. He asked the Justice how much he owed him, and the Justice told him, 'Oh, whatever you think she is worth.' So he gave the Justice a quarter, and the Justice gave him back fifteen cents in change.

A LETTER FROM MOMA

Dear Son,

I hated to see y'all move so far away, but I thought I would drop y'all a line to see how you're doing. Have you seen any of them Quakers since you moved to Pennsylvania? How's the weather up there? We had a bad thunderstorm the other day, and the wind blew so hard that it stretched the phone lines so bad that now it's long-distance to call our neighbor across the street. We don't even get The GRAND Ole Opry till Wednesday night. It rained until the water got up to the bottom strand of wire on Aunt Elsie's barbed wire fence, but it didn't cross over into our yard.

Your dad heard on the Knoxville news that most accidents happen within 25 miles of home, so we moved 26 miles from Crab Orchard to feel safe. Your dad took the house numbers with him so we wouldn't have to change our address. I sure miss them kisses. Your sister had her baby this morning, but I'll declare I forgot to ask her if it was a boy or girl, so I don't know if you'll be an uncle or aunt.

Your uncle Albert went over to Gadhair Daggett's moonshine still in Bat Town, and he leaned over the vat to get himself a nip, but he slipped and fell in. Gadhair's men tried to get him out, but he fought them off so bad that he drowned. So, they cremated him, and he burned for three days. If you ever get to go to Philadelphia, tell that Franklin man that we said hello.

I'll close for now.

Miss You,
Mom

GROUND SOW HUTTEN

I was sitting in front of Kemmer's Grocery store on Lier's Bench when this fellow named Hog came over and sat down beside me. He asked if he'd ever told me about the time he went groundhog hunting. I said no, I didn't think so. So he began his story:

"Well, this hill ran upon me, and we treed a groundhog on a hickory, sycamore, or maybe a black cherry sapling. There he sat about forty feet above. My little brother aimed at him and shot but missed, so I took aim and shot, hitting him right where my little brother had missed. Down he fell, kerflop. I ran up to him and threw my shoulder around him, but he wasn't quite dead, so he turned around and bit a hole in my ear. That's why I wear this earring to this day.

My little grandkids wanted to see the groundhog, so I took them down to the house. But when we got there, I found the house all closed up, and the doors were stuck in the bed. I looked outside, and all the gates were in the garden. Every cabbage head was running around with a pig in its mouth. Well, that made me so mad that I ran my pockets down into my hands and pulled their tails out and cut my knife off.

We skinned the groundhog, put salt and pepper on it with a lot of spices, but it still tasted so bad that we threw it all in the garbage and baked the carving board. It wasn't that bad."

THAT'S WHAT I'D LIKE TO DO

Bill and his brother William were sitting on their front porch, just watching the cars and trucks go up and down Highway 70. They lived with their Momma between Crab Orchard and Ozon, down toward Renfrow Holler. One day, they were contemplating mowing the yard but couldn't find the lawnmower because the grass was so high.

Their momma, Bessie, had just made them move the transmissions, car hub, brake shoes, and hubcaps out of the driveway so she could get out and go to the store to buy some meal. She needed it to make corn-bread to go with the pinto beans she had cooked all day. As they were sitting there on the front porch, a big truck load of sod passed by. Bill said to William, "Now, that's what I want to do when I hit the lottery."

William asked, "What's that?"

Bill replied, "Send this yard out to get it mowed."

BE CARFUL NOW

Joe was watching the news on WATE in Knoxville when the anchor read a news flash. It stated that some nutcase was driving west in the eastbound lane of I-40. Joe's wife had been shopping at West Town Mall, so Joe called her on her cell phone and informed her about the situation, mentioning the wrong lane incident. She replied, "It looks like two or three hundred to me."

WHERE'S MY CIGARETTS?

Jim B. from Dorton, a carpet store owner in Crossville known for offering fair prices and doing great work, found himself facing an unusual situation. He had sold a carpet job to a lady in Crab Orchard and was in the process of laying her carpet. Everything looked perfect except for a small hump under the carpet.

Jim reached into his shirt pocket to retrieve a cigarette but realized they were missing. He thought he might have dropped them on the floor and accidentally covered them with the carpet. Instead of removing the carpet to search for them, he decided to gently tap the area with his hammer, hoping to make the cigarettes less noticeable.

As he was working on the carpet, the lady of the house walked into the room and said, "I found your cigarettes on the counter. Have you seen my gerbil anywhere?"

WE GOT OUT OF THAT FIELD
JUST IN TIME!

A young man from Linary named Wesley T. had just purchased a new Dodge Charger from East Tennessee Dodge and decided to take it down Highway 70 E for a test drive. Meanwhile, two farmers had been standing in a field discussing the crops they planned to plant in the spring. Their conversation led them closer to the road as they chatted.

As they continued talking, a boy came speeding down the road but couldn't navigate the curve ahead. He ended up going up a bank, and his Charger went airborne, landing precisely where the two farmers had been standing just moments earlier. Fortunately, no one got hurt. One of the farmers turned to the other and said, "Boy, it's a good thing we left the field; otherwise, we would have been run over."

AIR DISASTER

In a Birmingham, Alabama newspaper one evening, a headline read: 'Alabama's Worst Air Disaster Occurs as Small Two-Seat Cessna Crashes in Cemetery near Gadsden along I-65.' Search and rescue workers have recovered 1,822 bodies, and they expect that number to rise as digging continues.

YES YES I WILL!

This widower and widow had become really good friends. Over time, the widower fell in love and thought they needed to get married. After dinner, he asked her if she would marry him, and she enthusiastically responded, 'Oh yes, yes, I will, I will!' They went their separate ways. The next morning, the widower called the widow and said, 'I know I asked you to marry me last night, but I can't remember if you said yes or no, and I am so embarrassed.' The widow said, 'Oh, I'm so glad you called. I did say yes, yes, I will, but I couldn't remember who asked me.'

THESE ARE OLD

Lonnie B. from Crab Orchard went to the Natural History Museum in Nashville and was looking at dinosaur bones. He asked one of the scientists how old he thought the bones were. The scientist told him, 'They are three million and four years old.' So Lonnie asked him, 'How can you be so precise?' The scientist explained, 'Well, when we found them, they were three million years old. So, I have been working on them for four years, marking it as three million and four years.'

.

TURNER TOILET SERVICES

My cousin Paul Holt was a pastor in Rogersville, Tennessee, and he was a whiz on a computer. At the time, I knew very little about computers, so I needed some flyers made. I called Paul and asked him if he could make me some flyers if I sent him a rough design. He said he'd be glad to do it for me.

Well, I thought I'd have a little fun with it, so I addressed the envelope this way: 'APOSTLE PAUL HOLT WORLDWIDE MINISTRIES, C/O PROPHETESS BARBARA HOLT.' I didn't think much about it until Paul called me and said, 'Jimmie, I've lived in this house for six years and have never had one problem with my mail until today. My neighbor brought this envelope over to my door and said, "Is this your mail?"' Then I tried to explain to him that I had a nutty cousin from Crossville who is always trying to pull something on somebody. The man just looked at me and said, 'HUM' and walked off.

Well, a couple of weeks later, I went to pick up my package of flyers from Paul. I had to go to the post office to get the big envelope. When the Postmaster brought my package, she looked at the address and then looked at me and said, 'I didn't know you were in the plumbing business. I've got a toilet that's been leaking, and I'd like to get you to come fix it for me.' When I got the big envelope with my flyers, the address in big bold letters said: 'TURNER TOILET SERVICES.'"

PREACHERS LOVE FRIED CHICKEN

A pastor friend of mine was having a baptismal service out in Byrds Creek, just off Highland Lane between Dorton and Homestead. It was going very well with a big crowd gathered all around until the pastor got in a bit too deep in the creek and preached his false teeth out. Some of the young boys were recruited to dive into the creek and try

to find his teeth, but they had no luck in their search. Finally, an old boy named Luther from Chesnutt Hill spoke up and said, "Wait a minute, I've got an idea." He went to his pickup, got a piece of fishing line, tied a chicken bone to it, and threw it out in the creek. The teeth latched right onto that bone.

THEY LOOK JUST LIKE US

Ted R. took John B. and me to a fancy restaurant in Cookeville, but unbeknownst to us, one whole wall was covered with a mirror, making the place seem much larger than it was. We were sitting there, waiting to be served, when John said, "Over there, three old boys are sitting, and they look just like us!" I replied, "Boy, they do, and they're even dressed like us!" Teddy got up and suggested, "Let's go over there and talk to them." As we started to walk over, Johnny paused and said, "Wait a minute, boys, looks like they're coming over here."

GERONIMO

One of my best pastor friends, named Lee Carbaugh, served for many years at several churches. He had a great sense of humor. One hot and muggy Sunday morning, he began his sermon. Back then, there was no air conditioning, and he had just eaten a green mint. As he preached about tithes and offerings, he started sweating profusely and wiping his face with his handkerchief.

While preaching about money, some of the green from the mint got on his lips, and people in the congregation began to laugh. To make matters more amusing, the State Bishop happened to be present that day and couldn't help but join in the laughter. Brother Carbaugh, noticing the laughter, became frustrated and defensive. He suddenly reared back and jumped over the pulpit, exclaiming, 'GERONIMO! TOO MANY CHIEFS AND NOT ENOUGH INDIANS AROUND HERE!'

LET ME PRAY NOW

My wife and I were pastoring a small church in Elwood City, Pennsylvania, and I would always go over to the church to pray. Back then, I prayed really loudly, and I guess most of the neighborhood could hear me. There was a group of kids in the neighborhood who were good kids, but they loved to aggravate me. Sometimes, they would bang on the windows and doors.

Once in a while, I would go out and be friendly with them, and they'd stop for a while. One day, I was deeply engrossed in a prayer, but here they came, banging and hollering again. I thought I needed to do something to get them to stop. So, while still praying, I quietly moved back to the front door of the church and opened it. Without breaking my prayer, I cut out after these kids and chased them down through several yards beside the street. Of course, they knew I was playing with them.

Then, I looked down toward the end of the street and saw a familiar Buick coming up the street. As it got closer, I realized it was the Overseer of the State of Pennsylvania. He pulled up beside me, rolled down his window, and asked, 'What are you doing, Brother Turner?' I replied, 'I'm chasing these kids.' Brother E. Eugene Johnson said, 'Okay, you go ahead and catch them, and I'll see you up at the church.' I felt about two inches tall."

WHERE ARE WE AT ANYWAY

Two good buddies and business associates named Ralph and Tom from the city of Crossville went on an elk hunting trip to an elk hunting reserve in Western North Carolina. A pilot friend of theirs flew them over to a landing strip very close to the area they would be hunting in. They stayed over there for one week and actually killed two elk, with one weighing about 1,700 pounds and the other one weighing

right at 1,550 pounds. They called their friend Nick, who owned the two-engine Cessna, and told him they were ready to come home. When he landed, he saw that Ralph and Tom had too much meat for the weight limits of his plane. So Nick told them, "Boys, I hate to tell you, but I can't haul all this meat and you all and me on this plane at the same time." But Ralph and Tom told him that it wasn't all that heavy, and finally, Nick agreed to load the meat on the plane and get them all back home. Well, the plane got off the ground but began to descend, and they crash-landed in a grove of pine trees. They were not hurt too badly, except for being bruised up pretty bad. Ralph raised up out of the floorboard and started hollering, "Where are we at, where are we at?" So Nick said, "About three hundred yards past where we got last year."

SURGERY IN DADDY'S CREEK

One day, this young boy named Slick and I decided to go fishing in Daddy's Creek. We got up real early, and my wife Morine and my sister Joyce dropped us off three or four miles up the creek above Cline's Camp, where they were to meet us and have supper ready. We were wading down through the long water hole at Cline's Camp when Slick hooked a big Smallmouth Bass that weighed close to six pounds. To this day, it's one of the largest Smallmouths ever caught out of Daddy's Creek.

I got real excited and cast out my three-hook Rapalas, and one of them struck Slick right in the back of his neck. He said, "Turner, if I lose this bass, you are a dead duck." So I took his razor-sharp Tree Brand Booker knife and cut the hooks out of his neck. Then we went on down the creek and met Morine and Joyce, and they had fried potatoes and bacon, and everything turned out good.

I DID NOT MEAN TO MAKE THEM MAD

In all the years of pastoring churches, I would say that Pine Grove, right outside of Crossville, was the highlight of my ministerial life. They were good people and treated my wife and me very well, and we did love all of them very much, but they did not laugh very much.

One Sunday morning after the Sunday School Superintendent turned the service over to me, I decided to share a humorous church bulletin blooper to lighten the mood. I read it aloud, and there was no reaction from the congregation. I thought, "Well, they didn't find it funny." However, after the service, a sister from the church came up to me and said, "Pastor, I didn't appreciate your joke this morning." Confused, I asked her why it upset her. She replied, "You put in the bulletin that we were going to have a dinner tonight, and there ain't but about four of us women over there that have cooked!"

I tried to explain that it was meant to be a lighthearted blooper, and I pointed out that at the top of the page, it clearly stated, "The following are church bulletin bloopers." This sister, however, remained upset and stormed off, saying, "Don't be putting bloopers in our bulletin." After that incident, I thought to myself, "I'll never try to be funny here again."

YOU TALK ABOUT BAD LUCK

I don't really believe in luck one way or the other, but the story I'm telling here is very true, and it all happened to a good friend of mine who was pastoring a small church in West Virginia. He and his wife decided to go on a trip to Florida, so they headed south on US 19, and they got in the middle of the New River Gorge Bridge, which is 879 feet above the river below, and their car quit. Brice was able to get it towed into the next town and get it fixed. When they got back home after vacation, they shared their experiences with the congregation.

One Sunday, before the superintendent turned the service over to me, I told them that Charley and I had been out horseback riding, and that the horses got spooked, and they started bucking. I mentioned that if the manager of Walmart hadn't come out and unplugged them, we boys might have gotten hurt real bad. Surprisingly, nobody laughed at all, so I just went on and brought my sermon.

The next Sunday, before the superintendent turned the service over to me, he said, "Our pastor is a really good guitar player, and he plays by ear; that's why they are so big," but again, nobody laughed.

Regarding Brice's car troubles, his engine went out on him again, so this time he had to find a different engine. He caught a ride with a man into town, but when they got almost to town, the man had a head-on collision with another car. Although they weren't going very fast, the man had a heated exchange with the other driver and then had a heart attack and died. Brice found another engine but had to go back home to find someone to retrieve it for him.

Another time, Brice was a local Radio Talk Show host known for his intelligence and ability to carry on intelligent conversations. During a live broadcast, the station manager ran in and informed Brice that his car was on fire. Brice rushed to the parking lot, but by the time he reached his car, all that was left was the trunk.

A few months later, Brice and his wife came to our place in Tennessee, and I took him to Chattanooga to talk to his attorney about his various car accidents and mishaps.

MAN, WHAT A CATCH

A friend of mine from Burgess Town named Doyle T. went fishing at the old City Lake one day and was being very successful until a friendly red squirrel started playing around in a bush next to him. He tried to scare the squirrel away, but it kept coming back, and it began to annoy Doyle. Frustrated, he took his fishing rod and tapped the little critter on the head, causing it to fall to the ground as if it were dead. Doyle left the squirrel where it fell, not realizing what would happen next.

Soon, he saw the game warden approaching, and he knew that killing a squirrel out of season could get him in trouble. To avoid being caught, he picked up the seemingly lifeless squirrel and threw it into the bottom of his tackle box. As the game warden drew closer, he heard scratching noises coming from the tackle box. Doyle quickly reached into the box, grabbed the squirrel, and tossed it into the lake as far as he could.

When the game warden arrived and started a conversation with Doyle, the unexpected happened. The squirrel, now swimming in the lake, had a Bream, a Smallmouth Bass, and a Shell Cracker attached to it as it approached them.

JUST WAITING

A friend of mine went into the Dairy Queen here in Crossville to get some lunch. While he was eating, he noticed a couple sitting in the booth across the room from him, but only the man was eating. Joe figured they might not have enough money for both of them, so he went over to them and told the woman he would be glad to buy her some lunch. However, she said, "No, I'm just waiting," so he went back and sat down.

A few minutes later, he saw that the woman was still not eating, so he went back over and told her that he wouldn't mind buying her some lunch. Once again, the woman said, "I'm just waiting." Joe asked her, "Ma'am, what are you waiting for?" She replied, "The teeth."

LET'S START US DO A THING STORE

William B. from Cox Valley Road, a suburb of Crab Orchard, won the state lottery, a total of $10,000. He and his brother Bill decided to take a trip to Nashville for a couple of days to enjoy the Grand Ole Opry and visit the Ernest Tubb Record Shop, thanks to their new-found wealth. This marked one of the first times they had ventured out of Cumberland County, and they were quite unfamiliar with the ways of the big city.

As they strolled down Broadway and took a left onto Second Avenue, they spotted a sign that advertised unbelievable prices for clothing: Men's Suits for $8.00, Men's Shirts for $4.00, Slacks for $4.00, Women's Tops for $3.00, and so on. William turned to Bill and exclaimed, "With clothing prices like that, we could start our own clothing store in Crab Orchard and make some serious money!"

After a brief discussion about their plans and what they wanted to stock initially, William added a strategic tip, "If the owner asks where we're from, tell him Crossville. That way, he'll think we're experienced businessmen who know what we're doing."

Confident in their plan, they entered the establishment, and the man behind the counter inquired, "Can I help you gentlemen?" William replied, "Yes, sir, we'd like to purchase 100 men's suits, 100 pairs of slacks, 100 women's tops, and 100 women's slacks." Curious, the owner asked, "Where are you guys from?" Bill confidently responded, "We're from Crossville." The owner chuckled and said, "No, you're not; you're from Crab Orchard." Confused, Bill asked, "What makes you say that?" To which the owner replied, "Because this is a dry cleaners."

CALL THE LAW

Joe W. resided on the road connecting Ozone to Alloway, and he was suffering from an ingrown toenail that was causing him significant pain. His constant moaning and groaning about the issue caught the attention of Lester T., who overheard Joe discussing it at Kemmer's Grocery store one day. Lester, claiming to be a doctor, offered to remove the ingrown toenail for Joe, assuring him that it would be a painless procedure for one hundred dollars. Joe, desperate for relief, agreed to the proposition.

Lester went to Gaghair's still in Bat Town and procured a pint of 100-proof moonshine. He then visited Joe's house, instructing Joe to consume about half of the moonshine before pouring the remainder onto his affected toe. Joe followed Lester's advice, and despite the moaning and groaning, Lester proceeded to remove Joe's toenail. However, the procedure left Joe's toe permanently damaged. Lester concluded by pouring the remaining moonshine on Joe's toe and wrapping it up.

Sometime later, Joe took action against Lester by sending a letter from the Tennessee Medical Association, resulting in Lester being fined $100.00 for practicing medicine without a license.

HOME ON VACATION

My brother Charley, along with his wife Christine and their son, returned to Crossville for a short vacation and decided to take a detour off the Interstate to drive through town on US 70 to see if anything had changed. During their drive, a constable named Carson noticed them and activated the yellow mobile home escort light on top of his car to pull them over.

Upon approaching the vehicle, Constable Carson asked Charley to explain the purpose of their visit. Charley mentioned that they were on vacation from Detroit. Carson proceeded to examine the license plate on Charley's vehicle and then returned to the window, asking, "Did you say you were from Detroit?" Charley confirmed, and Carson followed up with, "If you're from Detroit, what are you doing with these Michigan license plates on this thing?"

CRAB ORCHARD CAFÉ

After returning home for a couple of days, a friend called me and inquired about the little cafe in Crab Orchard, where he used to enjoy fried frog legs. I confirmed that the cafe was still open, and he suggested that he pick me up in the morning to go there for breakfast and enjoy some of those delicious fried frog legs. I happily agreed to join him.

The next morning, my friend picked me up, and we entered the cafe. We found a table and were soon approached by a waitress who had a slight limp and moved somewhat slowly. Charley asked her, "Do you have frog legs?" To which she replied, "No, arthritis is what causes me to walk like this."

As we were enjoying our meal, a man from up north entered the cafe and sat down. He called the waitress over and placed his order, asking for two eggs over easy, bacon, and a bagel. She returned a few minutes later and said, "Sir, here's your bacon and eggs, but the boss said to tell you that he's sold all his beagle hounds."

DO THESE GET ANY BIGGER?

This young man had recently landed a job at Food City in Crossville. Originally from Hebbertburg, a suburb of Crab Orchard, he wasn't accustomed to dealing with customers and could be a bit straightforward in his responses, though it was never meant to be offensive. He worked in the meat department, and one day, just before Thanksgiving, he was busy stocking turkeys. A somewhat posh lady approached him, perusing the turkeys, and inquired, "Is this as big as these things get?" Gary, without missing a beat, replied, "Yes, ma'am, they're dead."

I'VE GOT ONE LIKE THAT

One day, a Texan experienced a flat tire on I-40, not far from the Crab Orchard exit. He pulled into a Shell Station to have his flat fixed. Spotting Clyde S. tilling his garden nearby, the Texan decided to strike up a conversation with him while waiting for his tire to be repaired. The Texan asked Clyde about the size of his land, to which Clyde mentioned having about an acre and a half. Curious, Clyde then inquired about the Texan's property. The Texan proudly proclaimed, "Well, I can get in my pickup and drive all day and never leave my property!" Clyde, with a chuckle, responded, "Yeah, I used to have a pickup like that."

HARRY TATORS

While visiting Howard Shirrell's Grocery store, I ran into my uncle Agbert. We exchanged a few words about the chilly weather and the approaching Christmas holiday. I asked Agbert if he was prepared for Christmas, and he mentioned he had come down to the store to find something for Effy. As we stood there chatting, Agbert picked up a large coconut and called out, "Hey Howard, how much are these big

hairy taters per pound?" Then, he turned to me and remarked, "I've never seen anything like this before."

A LITTLE BIT OF CRAB ORCHARD SLANG

It's put near there. I'll be back directly. My tongue got twisted around my eye tooth, and I couldn't see what I was saying. It's not worth a hoot and a holler. Grinning like a possum while sitting out there on the liar's bench. He's dumber than a coal bucket. Colder than a well digger's rear end. Ain't you got anyone better, Nat? Jeet? Yont to? Sko. It doesn't make me no nevermind. I wish you'd be a little more specific about what you're asking; I might be able to help you out more. He's not the sharpest tool in the shed. That's slicker than deer guts on a doorknob. Has a cat got a meow? That girl's so touched; she ate Cool-Aid in a slop jar. She dropped him like a wet dishrag. He's not the brightest bulb in the socket. Somebody's hit that girl with an ugly stick, and he's as clumsy as a bull in a china shop. Bankers and lawyers are just like a hoot owl; they sleep with one eye open, and it's dangerous to skinny-dip with snapping turtles. That old gal is level-headed; the tobacco juice runs down both sides of her mouth evenly.

HILLBILLIES FROM BURGESSTOWN

Gomer Dunks, who married Effy Hoehandle, had two rowdy kids and lived down Glens Cove Road, right below where Clear Creek flowed. They made their way into town occasionally to stock up on essentials like chewing tobacco and snuff. One day, they stopped in at the Laminax Hardware store. The man at the counter asked, "Can I help you all?" Gomer replied, "Yeah, give me a twist of King Bee" (chewing tobacco). The man said, "We don't sell anything but hardware in here." Gomer retorted, "Well, just give me a twist of hardware then."

THE BIGGEST CROP OF CORN

My friend Larry, from Clark Range, Tennessee, went to the local Farmer's Co-op in Crossville and struck up a conversation with one of the good ol' boys working there. The man told Larry that they had come out with some of the best fertilizer that the state of Tennessee had ever seen. He claimed it would make corn grow with two huge ears on one stalk, each at least twelve inches long.

Larry told the man at the Co-op that he had chicken manure that could beat that by a long shot. They argued back and forth for a while. Finally, Larry challenged the man, saying he had an extra field that year. He proposed that the Co-op folks come out to his farm to plant an acre using their new fertilizer while he planted an acre using his fine chicken manure.

So, the Co-op men came out and planted an acre using their special fertilizer, and Larry planted his acre with his fine chicken manure. Both acres of corn grew impressively. Larry even drove a row of tobacco sticks along the edge of his acre just to see if his corn would grow taller than the sticks.

At harvest time, the Co-op men came out, and sure enough, their corn had reached ten feet tall, with each stalk bearing two ears, each twelve inches long. They thought that was wonderful. However, when they checked Larry's crop, every stalk had three ears, each fourteen inches long, and there was a nubbin on every tobacco stick.

WELL, ROWED YOU KNOW?

I went over to see Leland S. in Bat Town one day to see if I could borrow his corn sheller, so we could get our crop ready to go and get it ground into meal. Well, Leland's wife, Sheila May, came to the door and told me that Leland had gone possum hunting and that he was supposed to be coming home any minute, so I could sit on the front porch swing and wait there if I wanted to. In about ten minutes, here comes Leland out of the woods with a tow sack on his back. He walked up to the porch and said, "Howdy, Jim, guess how many possums I've got in this sack, and I'll give you both of 'em." I said, "Two," and Leland said, "Somebody done went and told you."

THEY'RE ON THE TRUCK

Tony B. lived on Chestnut Hill Road for many years and worked at Crossville Cash Home Center for a few years. He delivered a load of shingles to Crossville Medical Center. When he walked into the lobby, he went over to the front desk and told the lady that he had the shingles. She told him to have a seat and that they would get to him in just a few minutes. Tony was a good old country boy, so he just thought this was their procedure for people delivering stuff to a Medical Center. In a few minutes, a nurse came out and told Tony to follow her. She took him into the hallway and weighed him, took his blood pressure, and then took him into a little room. She told him the doctor would be in to check him in just a moment. The doctor came in and told him to pull his shirt off, then looked him over and said, "I don't see any sign of shingles." Tony replied, "No, Sir, they're out there on the back of the truck."

ARE YOU ABOUT TO GET 'EM?

Oscar D. had a small pig farm over in Daysville, and he also had honey bees and sold honey, which was the best you could buy around the plateau area. One day, a bee stung him, and he chased it about half a

mile trying to kill it. My dad, Walter, went to visit Oscar one day. When he knocked on his door, Oscar's wife told my dad that Oscar was down in the barnyard. So Dad went down there and asked Oscar what he was doing. Oscar said, "I'm counting my pigs." Dad asked, "Have you about got them all counted?" Oscar said, "Yeah, all of 'em but one, and it won't be still enough for me to count it."

GIVE ME SOME YOUTH PILLS

Bill P. ordered some youth pills that were supposed to take twenty years off your age if you took two pills a day for thirty days. So he thought he'd take four a day and that would take forty years off. One day, he was standing down by the road crying, so his wife asked him what was wrong. He said, "I missed the school bus."

ADVENTURES ON DOCTOR NEVIL'S FARM

My dad, Walter Turner, was a sharecropper on Dr. R. S. Nevil's farm, and he, along with my mom and us kids, lived there for six years. At times, it was really tough to make ends meet. Dr. Nevil was a good-hearted man who always made sure we got by. He ensured we had a hog to butcher and made sure we had a good Christmas every year.

Across the Lantana Road from our place, there lived an old gentleman who was a banjo player in the style of Grandpa Jones. My brother Gene, Mr. Hammonds, and I used to hide in the dense bushes along the side of the road. We'd tie a piece of fishing line onto a woman's purse and toss it out along the side of the road. When someone stopped to retrieve it, Gene would give it a sharp tug, which would startle them tremendously.

One day, a logging truck pulled over, and the driver began to get out to inspect the purse. However, a girl named Fields, who happened to be walking by, yelled at the truck driver, "Don't you touch that purse; it belongs to my sister!" The truck driver stayed put. When the girl bent down to pick up the purse, Gene gave it a strong tug, and she screamed as if she'd been bitten by a snake and sprinted back toward her house. That would always bring immense joy to old man Hammonds.

Another day, a fellow named Marshall walked up the road, and you could hear him saying, "Oh boy, Oh boy, Oh boy!" But when he tried to pick up the purse, Gene yanked it, and Marshall started running backward, exclaiming, "Ouh, Ouh, Ouh!" Once again, Old man Hammonds couldn't stop laughing.

My dad had about ten acres of corn planted along the Lantana Road, and he and my mom were busy clearing thistles from the cornfield on

a scorching 90-degree day. I went over and told Mr. Hammonds that Dad wanted to know if he could come over and play his banjo while they worked on the corn. In just a few minutes, Mr. Hammonds brought his stool and his banjo right out to the middle of that corn-field. He started playing and singing some bluegrass music. I'll never forget the look on my dad's face when he saw him there and said, "What in the world is he doing out here?"

This is an absolutely true story.

FARMER'S TECHNICAL TERMS
ABOUT COMPUTERS

- Log On: Putting another log on the fire to warm the house.
- Log Off: Removing a cut tree from the stump.
- Mega Hertz: The need for caution when cutting firewood to avoid getting hurt.
- Laptop: Where the cat sleeps when you take a rest.
- Hard Drive: Referring to difficult terrain when navigating the northern part of your farm.
- Windows: What you close at night to keep the wind and rain out.
- Byte: What you get from mosquitoes when you leave the window open.
- Keyboard: What you learn to play the piano on, also used to hang your farm implement keys.
- Mouse: A critter that can infest your corn crib and damage a lot of corn.

CUMBERLAND COUNTY TENNESSEE

Cumberland County, Tennessee, is one of the most beautiful counties in the state of Tennessee, and it is a wonderful place to raise a family. The county would be complete if we had a Dollar General Store on Tabor Loop, Bowman Loop, one on the Plateau Road, one in downtown Browntown, one in Creston, one in Burgess Town, one in Merridian, one in Grassy Cove, one on Cox Valley Road, one in the city of Bat Town, one over behind Griever's Chapel Baptist Church, one down in Hebbertsburg, and one on top of Black Mountain.

WHAT AN ACCIDENT

There was a farmer who lived past Tanzi Resort named Obrian. He ran into a trailer on the back of his pickup that was loaded with fertilizer. Later, an officer asked Farmer Obrian, "At the scene of the accident, didn't I hear you say that you had never felt so good in your life? Now you claim you were seriously injured and want to collect some money from your insurance?" Farmer Obrian said, "Yeah, you saw my dog had a broken leg, and you shot and killed him, and I THOUGHT I'd better say I was feeling fine."

THAT'S A DEAD DUCK

A woman named Joyce who lives out on Tabor Loop brought her very limp pet duck to the veterinary hospital in Crossville. When she laid it on the table, the vet doctor pulled out his stethoscope and listened to the bird's chest. After a moment or two, the doctor sadly shook his head and told Joyce that the bird was dead. The distressed woman said, "Are you sure?" "Yes, I am," the vet doctor said, "your duck is dead."

The woman said, "I think that Cuddles has just had a heart attack or stroke or something, so can't you run some more tests on him and see?" The doctor opened the door, and a big Labrador Retriever dog came walking into the room. He went over and sniffed all over the duck and then walked back out. After the dog, a big tomcat came in, jumped up on the table, sniffed all over the duck, and then jumped off and left the room.

The doctor said to the woman, "Ma'am, your duck is dead, and that will be $150.00." Joyce said, "You mean to tell me you're going to tell me my duck is dead and charge me $150.00?" The doctor replied, "Well, if you had believed me when I first told you your pet duck was dead, it would have only cost you $20.00. But after the lab work and the CAT scan, it is now $150.00."

GOODBYE MOTHER

A young man was walking through a supermarket, picking up a few things when he noticed an old lady following him around. Finally, he got up to the checkout line, but she got in front of him.

"Pardon me," she said, "I'm sorry if my staring at you made you feel uncomfortable, but you look just like my son who recently died."

"Oh, I'm sorry," replied the young man. "Is there anything I can do for you?"

"Yes," she said, "As I'm leaving, you can say, 'Goodbye mother?' It would make me feel so much better."

"Sure," answered the young man.

As the old woman was leaving, he called out, "Goodbye, Mother."

As he stepped up to the checkout counter, he saw that his total bill was $127.55. "How can that be?" he asked, "I only purchased a few things."

"Your mother said you would pay for hers," said the clerk.

HE WANTS TO GET MARRIED

A little boy told his dad that he wanted to get married. His dad asked, "Why, son? You're only five years old. Who are you going to get married to?" The boy replied, "Grandma." The dad asked, "Why would you want to marry Grandma?" The little boy said, "Because she's a good cook, and she gives me toys and stuff." The dad said, "But son, you can't marry Grandma because she's my mother." The young man replied, "Well, Dad, you married my mother."

HOW DO YOU ALWAYS GET SOMEWHERE

A woman's shed caught on fire, and she called the local Fire Department. She told the man who answered, "My shed is on fire, and I need you to hurry down here and put it out." The fireman asked, "OK, how do we get there?" The woman replied, "Don't you all usually drive one of them big red trucks?"

GET THEM BRAKES FIXED

The Walmart store caught on fire, prompting fire departments from Monterey, Sparta, Rockwood, and various other towns to respond in an attempt to extinguish the blaze. However, the fire persisted. Then, the Crab Orchard Fire Department arrived and sped through the parking lot, smashing through the front doors. They managed to get inside and successfully put out the fire.

Some Walmart officials from Bentonville, Arkansas, arrived and presented the Crab Orchard Fire Department with a check for $20,000. Afterward, one of the officials asked the fire chief what he intended to do with the money. The chief responded, "The first thing we're going to do is get the brakes fixed on this truck."

I AIN'T GOT TIME

Gomer and Effy had been married for several years, and Gomer was still deeply in love with Effy. He wanted to keep her looking as pretty as possible for as long as he could, so he made an effort to take care of her. One day, Gomer told Effy to take his '52 Ford Pickup and go to the Dollar Tree to get herself a perm from one of the hairstylists at a beauty shop. While she was at the store, she bought some makeup and a lovely perfume. She went ahead and had the perm done, but before the hairstylist started, she asked Effy if she wanted a shampoo. Effy replied, "No, I ain't got time to eat it right now, just go ahead and work on my hair."

LET'S GO TO DAYTON

Billy Dale and Walter Dale were drinking Bat Town Blackberry wine one day and decided to go to Dayton, Ohio, to visit their brother, who worked there. They didn't have his address, so they thought they could ask around once they got there, and someone would surely know where he lived. So they set out on their journey.

They stopped in downtown Crab Orchard and picked up a couple of friends to go along with them. They pooled most of their money to fill up their '52 Chevy with gas. Billy Dale assured everyone that once they reached Dayton, their brother Luther would provide them with money to get back home.

As they drove around Dayton, they asked various people if they knew where Luther lived, but, of course, nobody did. Disappointed, they began their journey back home and reached just below Cincinnati. They stopped and traded their shoes for some gas. They got almost back to Crab Orchard and were running on empty. Billy Dale pulled into a gas station, looked around, and said, "Alright, boys, get them britches off."

GOT YA THIS TIME, OLE BUDDY

Jerry S. was known for his erratic driving around the Plateau area of Tennessee and had received several speeding tickets, but he didn't seem to ever learn his lesson. However, one day he did.

He was heading over to Oak Ridge High School to visit his old buddy Jeff, who had broken his leg in a farming accident. In a couple of weeks, Jerry received a ticket in the mail from the Oak Ridge Police Department. The ticket included a picture of his truck on the Oak Ridge Turnpike, caught going 55 in a 35 mph zone. This infuriated him because the ticket amounted to $100.00.

In response, Jerry decided to send them a picture of a one hundred-dollar bill. However, in a few days, he received an envelope in the mail from the Oak Ridge Police Department. When he opened it, he found a picture of a set of handcuffs inside. Jerry decided it was best to go ahead and pay the ticket.

TURNIP GREENS AND BISQUITS

I was teaching Bible study at Pine Grove Church one night, and somebody mentioned that they had to take potted meat sandwiches for their school lunch when they were a kid. Somehow, we got on the subject of how we were brought up so poor, and I'm sure some of us were. But an old boy named Rondal said to me, "Ole Jimmie Boy, why, when I was a boy in school, all I ever took for lunch was turnip greens and biscuits." So, one day, this old boy asked me if I would trade lunches with him, and I said, "sure." I handed him my turnip greens and biscuits, and he handed me his lunchbox, which was surprisingly heavy. I thought, "Yum, yum, I'm in for a treat now."

Then Rondal said that when he opened up the lunchbox, it was full of hickory nuts and had a hammer in it. Well, everybody laughed, so Rondal's mom was sitting there, and I asked her if that was the truth. She replied, "He has never taken a biscuit to school in his life."

TAKE HER TO WAL MART

My son-in-law, John Barnwell, called me the other day about some business. While we were talking, he mentioned that our neighbor was buying one of those Zero Turn lawnmowers. He told me that her cat had run out and got too close to it, resulting in its tail being cut clean off. I asked John what she did about it, and he replied, "Well, you know, she took it straight to Wal-Mart." I was puzzled and asked, "Why in the world would she take it to Wal-Mart?" He responded, "Well, you know, Wal-Mart is the largest retailer in America."

THAT'S ALL HE THINKS ABOUT

Back in the sixties, I worked at Crossville Rubber Products and was paid a significant wage, $1.225 per hour, but eventually got a raise of $1.40. I got tired of eating lard sandwiches, so my wife and I gathered enough courage to move to Michigan, where we started making good money.
While working at the Rubber Plant, a large, beautiful brown dog came to our house, and I started feeding him, and he stayed. One of my coworkers asked if I knew anyone who had a good squirrel dog for sale. I told him I had a big, beautiful dog for sale, but all he ever thinks about is hunting squirrels. He inquired about the price, and I told him it was $20.00. So, on a Friday evening after work, Jim came over and picked up old Rover. When we got back to work on Monday morning, Jim approached me and said, "Turner, I thought you told me that dog was a good squirrel dog. He couldn't even tree a possum." I clarified, "No, I didn't say he was a good squirrel dog; I said, 'All he thinks about is hunting squirrels.'"

THOSE FOLKS FROM BURGESS

Some of the finest and funniest people I have ever known live in a community called Burgess Town, which is located way down Lantana Road. If you take a right turn, you'll find them there. They absolutely

love to carry on and share funny stories, and the lady of the house is known as Ma, who is quite humorous herself.

One day, while I was visiting them, there was a knock at Ma's front door. When she opened the door, she greeted the visitor with, "Well, howdy, honey, how can I help you today?" A young girl who looked to be around ten or eleven replied, "Mama's going to cook a pot of pinto beans today, and she wanted to know if she could borrow your hambone." Ma responded, "Why, honey, I've got it loaned out today, but they're supposed to have it back to me by this evening, so you can come and get it then." The girl said, "Alright, I'll tell Momma."

On another evening, two of Ma's boys came in, completely out of breath, and told Ma, "Leave that door open, 'cause our rear ends will be dragging in here in a few minutes." Ma asked, "What in the world have you two been doing that's made you that tired?" One of them, named Buford, replied, "We've been changing a flat on a train." Ma said, "My goodness, they're coming out with everything nowadays!"

GREAT SHEEP DOG

One of Ma's sons had a remarkable sheepdog that could gather all his sheep into a single group and then effortlessly split them right down the middle before scattering them again.

Otas went to the stockyard in Crossville and struck up a conversation with a man who mentioned he was in search of a good sheepdog. Otas enthusiastically told the man, "I've got one of the best that's ever been, and I'll take $50.00 for him." The man inquired if he could come and watch the dog work sometime, to which Otas replied, "Certainly, feel free to come down anytime."

So, they agreed on a time, and the man came down the following Tuesday afternoon to witness the great sheepdog in action. Otas led the man to the field where all his sheep were, and then he commanded his Border Collie sheepdog, "Go get 'em, Bowser!" Without hesitation, Bowser sprinted down to where the sheep were scattered across the field and skillfully rounded them up into a single group. Once they were all gathered together, Otas hollered out, "Okay, Bowser, now cut 'em right down the middle!"

HE DON'T KNOW ANYTHING

This man's car broke down right in front of a farmer's field with cattle. He raised the hood and was inspecting his engine, trying to figure out what could be wrong. Then, a cow walked up, stuck its head under the hood, and said, "It sounds to me like you've got carburetor trouble. I think you're going to have to take it off and bring it to an auto repair shop to get it rebuilt." The man was stunned and stood there in disbelief.

At that moment, the farmer walked up and asked, "Is old Jersey bothering you?" The man replied, "Well, no, not exactly. I was just shocked to hear her talk." The farmer chuckled and said, "Yeah, I heard what she said, but I don't think it's your carburetor; I'd say it's your fuel pump. That is the dumbest cow I've got on this whole farm. She thinks she knows everything when she knows nothing. She's always sticking her nose into somebody else's business."

CAN'T WIN FOR LOSING

Luther from Bat Town and his wife drove over to West Town Mall off Kingston Pike in Knoxville to do some shopping. When they started back home, Luther stopped to fill up his car with gas. He always had to top it off and get his gas tank as full as possible. However, this time he spilled some gas on his left shirt sleeve.

As they got back onto I-40 West, Luther, being a heavy smoker, lit up a cigarette and accidentally caught his sleeve on fire. In a panic, he stuck his arm out the window, hoping the wind would extinguish the flames. Unfortunately, a vigilant cop saw him and pulled him over. The officer used a fire extinguisher to put out the fire on Luther's shirt sleeve.

Luther was grateful to the law officer for preventing a more serious burn, but the officer informed him, "You're welcome, but I still have to give you a ticket for brandishing a firearm."

THAT THING WASN'T WOORKING RIGHT

This good ole boy named Shorty, who would often joke about not being the sharpest tool in the toolbox (if you catch my drift, Vern), lived on the outskirts of Crab Orchard. His granny resided out on Cox Valley Road, perched on the side of a high bluff. Shorty once told me that she had killed many a man and thrown them off that bluff down into the holler.

Shorty had what was probably the ugliest '64 Burnt Orange Chevy Van in the state of Tennessee. It smoked like a mountain on fire, and you could see it from at least three miles away. One day, as we were chatting at the liar's bench by the courthouse, he shared a story about his van. He claimed that it could make the round trip to Rockwood and back on less than three quarts of oil and could even climb Spring City Mountain in reverse while in high gear. But here's what happened:

Shorty came into some money somehow and decided to visit East Tennessee Dodge when it first opened. He purchased a real pretty Dodge Conversion Van. He got onto I-40 at the Jamestown Exit and started back towards Crab Orchard. Then, he set the new van on cruise control and went to recline. Needless to say, it veered off to the right, ran up a bank, and hit a tree. When he woke up in the hospital and regained his senses, he told a buddy who was visiting him, "They didn't have that Cruise Control set up right, or I'd have never wrecked."

THERE HE GOES, BOYS

H.T. Campbell was a good old man who lived out toward Pumpkin Center, and the story goes that he and his wife would settle into bed at night. H.T. would hold a flashlight while his wife, Elsy, tried to

catch bed bugs. Whenever one of those pesky critters would scurry across the bed, H.T. would exclaim, "There goes one, Old Lady, catch him!"

H.T. also had a tradition of taking his boys rabbit hunting with him. When he spotted a rabbit, he would shoot it, and then he'd say, "Boys, I shot him! Now you all can go get him and bring him home." One of his sons shared with me one day at the Dairy Queen that he and his brother would chase that rabbit all day. They'd finally catch it when it ran into a brush pile. But what was interesting was that when they brought the rabbit home and dressed it, they would not find a single buckshot in it.

JUST PUTTING ON

The city police typically kept an eye on a particular bar in town, especially around closing time, to spot anyone who might be a little too tipsy to drive. One night, they watched as a man staggered out and attempted to get into several different cars and trucks, as if he were trying to find his own. Eventually, he located his own pickup, opened the door, and collapsed across the front seat. Afterward, he started the truck and moved it back and forth a few times while all the other patrons were leaving the parking lot.

Once everyone had departed, he pulled out into the street. Immediately, the cops pulled him over and instructed him to exit his truck and walk along the white line. To everyone's surprise, he executed the task perfectly. The officers then conducted a breathalyzer test on him, but it didn't detect any alcohol at all. Perplexed, the officer said to the man, "This alcohol detector is not functioning properly, so you will have to come down to the station with us for further testing." The man replied, "I will gladly go with you, but I should inform you that I am the Drunk Decoy for tonight."

I THINK I'VE GOT THE JOB

Jay B. from the Dorton community had always dreamed of a career in law enforcement, so when he heard that the Sheriff's Department was hiring, he decided to apply for the job. After filling out an application, the sheriff called him into his office for an interview. The sheriff said, "I'm going to ask you a few questions to see how you do." He began with, "Can you name two days of the week that start with a T?" Jay replied, "Yeah, that would be today and tomorrow." The sheriff chuckled and said, "That's not what I was looking for, but it's close enough." He asked Jay a few more questions, and he did reasonably well. Then the sheriff said, "I'm going to send you home with a tough question. Bring me the answer tomorrow. The question is, 'Who shot Abraham Lincoln?'" When Jay got home, his wife asked, "Did you get the job?" Jay replied, "I think so; they've already sent me on a murder investigation."

MY EMPLOYMENT OVER THE YEARS

My first job was at an orange juice factory, but I got fired because I couldn't concentrate. Then, I worked in the woods as a lumberjack, but I couldn't hack it, so they gave me the axe. After that, I tried my hand at tailoring, but I wasn't suited for it. Next, I attempted to work in a muffler factory, but I became totally exhausted. I wanted to become a barber, but I just couldn't cut it. I gave deli work a shot, but no matter how I sliced it, I couldn't cut the mustard. I studied for a long time to become a doctor, but I didn't have any patience. I pursued a career as a professional fisherman, but realized I couldn't make it on my net income. I landed a job working for a pool maintenance company, but the work was just too draining. After years of trying to find steady work, I finally got a job as a historian, but soon discovered there was no future in it.

WHAT IN THE WORLD IS THAT?

This farmer and his wife were sitting on their front porch, enjoying the nice summer breeze when they witnessed a transfer truck run over a rabbit, completely flattening it. The driver of the truck pulled over, got out, and reached under his seat to retrieve a can of something. He walked back to where the flattened rabbit lay in the ditch, sprayed whatever was in that can all over the rabbit, and then returned to his truck and drove off.

As the farmer and his wife watched from their porch, they were astonished to see the rabbit miraculously come back together, stand up, and begin hopping down the road. The rabbit even turned around and started waving at the couple. The old man said, "Well, I wonder what in the world was in that can." He went over and picked it up, and on the side of the can, it read: "HAIR RESTORER WITH PERMANENT WAVE."

A FEW FARMERS JOKES

Farmers are hard workers and give everything to their profession and they deserve to laugh once in a while when they come in from a hard day's work and lean back in their recliner and rest.

HERE ARE A FEW FUNNY
FARMERS RIDDLES!

Certainly, here are those farmer jokes with corrected grammar, punctuation, and edited for clarity:

1. How did the farmer find the cow? He tracked her down.

2. What conversation does the farmer have with the cow when he milks her? Udder nonsense.

3. How did the farmer get the highest marks in his math final exams? They were all protractors.

4. What should a farmer say to a cow when it comes his way? Mooooove.

5. What does a farmer say when one of his cows goes missing? Oh, I've made a terrible mis-steak.

6. What does a farmer call his next-door horse? His neigh-bor.

7. What kind of machine does a farmer use to make a circle? A pro-tractor.

8. What would you have if you crossed a robot and a tractor? A transformer.

9. Where does a farmer take his horse when he's sick? To a horsepital.

10. Where do farmers' kids go to grow up? The Kinder Garden.

11. Why do farmers go to watch movies often? To watch the trailers.

12. Why did the farmer bury cash in his soil? To make his farmland rich.

13. Why would a farmer not laugh at these jokes? Because they are all corny.

14. What do you call a happy farmer? A Jolly Rancher.

15. What did the farmer say to the cow who wouldn't go to sleep? It's pasture bedtime.

16. What do you call a cow without a calf? Decaffeinated.

17. What do you call a bull who always falls asleep? A Bull Dozer.

18. What are the favorite martial arts of a pig? Pork Chops.

19. What is a sheep's favorite game to play? Baaaadminton.

20. What is a dog on a farm called? A corndog.

21. Which farm animal is always checking the time? The watchdog.

22. Did you hear about the wooden tractor? It had wooden wheels and wouldn't even work.

23. What did baby corn ask mama corn? Where is popcorn?

THE FARM INSPECTOR

The Farm Agent came from the Farmers Association of Tennessee and told the local farmer he needed to gather some information from him. The farmer said, "Alright, I'll do the best I can, go ahead." So, the

farm agent asked him, "How much do you pay your top ranch hand?" The farmer replied, "I pay him $600.00 a week, and he gets free room and board." The agent continued, "Alright, how much do you pay your cook?" The farmer said, "I pay the cook $500.00 a week plus room and board." The agent nodded and said, "That's good. Do you have anybody else who works here?" The farmer replied, "Yeah, there's the half-wit who works for about 18 hours a day and makes about ten dollars, but he pays for his own room and board." The agent said, "That's the guy I need to talk to." The farmer pointed to himself and said, "You're looking at him, go ahead and talk."

THE PRIZE DONKEY

George was driving down a country road just outside the city limits of Crossville when he noticed a large crowd gathered around a farmhouse. He pulled into the place in his pickup and asked Farmer Doc Ellis what all the men were gathered around for. Farmer Ellis said, "Well, Joe's donkey kicked his mother-in-law in the head and killed her a while ago, so they hauled her off to the morgue." George said, "Oh, so all these men are gathered here to honor her?" Doc Ellis replied, "No, they're all here trying to buy Joe's mule."

GET THAT FARM GIRL'S NUMBER

Sally from Burgess Town was a farm girl who enjoyed fox hunting and was a member of the Fox & Hound Club out of Knoxville. She was at an event when an old Redneck boy from Crab Orchard approached her, trying to flirt. He kissed her on the cheek and said, "Hey, sweetie, how about giving me your phone number so I can call you sometime?" Sally asked, "Do you have a pen?" The boy replied, "I sure do." Sally said, "Well, you'd better get back and get in it before the farmer notices you're gone."

FLYING LOW

My eighth-grade school teacher's brother's name was Cam, and he was born and raised in Crab Orchard. He had been away in college for years and had worked for several years at Wright Patterson Air Force Base near Dayton, Ohio. When he retired and moved back to Crab Orchard, he was always trying to invent something and was successful in some things. He had a like-new Model A Ford and decided to make an airplane out of it. He researched and studied it for about a year and thought he had everything right, so he started on it. He had the propeller working, the wings were flapping right, and the back rudder mechanism seemed perfect. He had the engine fine-tuned to where it would purr like a kitten.

One day, Cam said to his mama, "It's time to try her out." He went downtown and found three of his friends brave enough to go on his maiden flight with him. They loaded into his plane, and Cam's mother watched everything. She came over close and hollered, "Now Cam, just fly around here low where the kids can see you." Cam had built some really long ramps so he could pull his new plane up on a 500-foot-long chicken barn for takeoff. The four were loaded in and ready to fly, so Cam floored that plane. It ran off the end of that barn and hit the ground, jarring all four of them. They were all black and blue, but none of them were bad enough to go to the hospital. After that great flight, when somebody would mention it to Cam, he would say, "You don't have to run it into the ground like I did."

A SENIOR MOMENT

Three sweet little senior ladies lived together in a house in Crossville. One night, Flo, who was 96, ran herself a bath. But when she started to step into the tub, she couldn't remember if she was getting in or out of the tub. She hollered downstairs to report her dilemma, so 94-year-

old Leah said she would be right up to check. But about halfway up the stairs, Leah couldn't remember if she was going up or down the stairs, so she called downstairs to ask.

The third little lady, Myrtle, who was knitting, looked up and thought, "I hope I never get as mentally foggy as those two." She rapped on the table to knock on wood, then said to the lady on the stairs, "Hold on a minute, till I see who's at the door."

CUT THEM LIGHTS OUT

Four good ole boys from Alloway, a small community, were always good buddies, but they liked to get out and have fun. They had a tendency to drink a little scorch, a reference to Tennessee Moonshine's potency because it scorches your throat when you drink it. These boys used to hold a gun on each other just to take a little nip.

One night, they were heading from Alloway to Ozone in Leo's 1952 Packard and were going way too fast. They couldn't make this curve and left the road, ending up in this older couple's living room. They were just a little idle, sitting in the car in this living room, so this old man came into the room out of his bedroom, putting his overalls on. He stood there, looked around a bit, and then said, "Alright, boys, cut them headlights out before you wake up everybody in the house."

FAT MULE FOR SALE

Odell lived way down Vanderver Road. To get there, you had to take a right and go way down a gravel road toward the top of Pikeville Mountain, about 12 miles from the blacktop. He had a male mule he wanted to fatten up and take to the Stock Sale in Crossville. He tried feeding him grain, apples, or whatever he could get him to eat, but the

mule would still stay so skinny you could see every rib. He was watching his wife make biscuits one morning and when he saw her put baking powder in them and saw how the biscuits would rise in the oven, he got to thinking that maybe that baking powder would blow up his mule and make him look fat enough to sell.

Odell put a little grain in the mule's trough and added a whole can of baking powder to it. The mule ate every bit of it, and it sure did work. It puffed that mule up and made him look so pretty and fat. Odell loaded "ole Daisy" into his pickup and took off for the stock sale. However, by the time he got there, the male mule had let out so much wind that he was as skinny as ever. So, Odell ended up selling him for $2.00.

JUST GO HOME WITH ME

This fellow from Jamestown, Tennessee, owned a lot of businesses in the area and would travel around the state. One day, he decided to take his girlfriend to the Grand Ole Opry in Nashville. They set out down I-40 toward Nashville, but he had been sipping a little of his favorite Bat Town Moonshine and had swerved while driving. A Tennessee State Police officer pulled him over. When the policeman came up to the window, he could smell the moonshine on John's breath. He asked, "How are we doing tonight?" John replied, "We're headed to the Opry."

The officer said, "You'd better come and go with me." John said, "No, we can't go tonight. Why don't you just come and go with us?" Then the officer said, "I'm going to have to put you under arrest for drinking while driving." John replied, "You can't arrest me." The policeman asked, "Why not?" John said, "I'm John Frog from over in Jamestown, Tennessee." The officer said, "Well, Mister Frog, you've jumped into the wrong pond tonight," and he took him and locked him in the Nashville Jail!

GRANNY, GO GET MY SHOTGUN

My grandpa Tige Turner lived up on Per Ridge, another suburb of Crab Orchard, with my step-grandma named Rose. They had heard about the coming days of a car but certainly had never seen one. One day, while Grandpa was sitting on the front porch, here came a T-Model Ford up the gravel road in front of their house. When Grandpa first saw it, he was scared almost to death, so he hollered as loud as he could for Rose to bring him his shotgun. He said, "Yonder comes the awfulest looking thing I've ever seen." As the car got right in front of the house, Grandpa shot at it, and the man driving ran off the road and jumped out, cutting across the field. Granny Rose ran out and asked, "Did you kill it?" Grandpa said, "I don't know if I killed it or not, but it sure turned that man loose."

TALK ABOUT A BIG ONE

I used to work at Crossville Rubber Products, and this story is about an old boy who happened to be my mother's first cousin. His name was Em, and everybody in the plant knew that he could tell some wild stories. He would come into the plant every morning with a new tale, especially one about deer hunting. One day, he was telling a big story about killing a big Ten-Point buck. A fellow named Otis asked Em if he could give him a big mess of deer. Em told him, "Sure, come by the house tomorrow evening when we get off, and I'll have it ready."

Well, Otis went by, and Em had it in a paper bag, all wrapped up for him when he handed it out the door to him. When Otis got home, he took his deer meat into the kitchen, took it out of the bag, and un-wrapped it. When he did, he found it to be two cans of opened and wrapped government commodity meat.

One day, I was eating my lunch, and I got to talking to Em. I knew he raised hogs, so I asked him what was the most pigs he had ever seen a

sow have at one time. He said, "Now, I'm gonna tell you the truth now, and I mean it. I had one that broke the state record, that sow had forty-four pigs at one time, and every single one of them lived."

GRANNY LEWIS WENT TO TOWN

Granny Lewis got most of her groceries from the Rolling Store and traded eggs or butter for them. But once in a while, she would venture into town to get supplies. One day, she stopped at Tabor's Fruit Market to get herself a watermelon. She asked Mr. Tabor how much they were, and he told her that the more she bought, the cheaper they would be. So she said to him, "Well, just load them in my pickup until they don't cost anything."

I WANT MY MONEY BACK

Granny's son Bo, who was the mayor of Greas Front, bought a lottery ticket at a convenience store in downtown Crab Orchard and actually won $10,000. It made news all over the metropolitan area of Crab Orchard, and he was really excited about it. He decided he wanted his winnings in a lump sum cash payment, so he went into the State Lottery office in Knoxville and told them he came for his money and he wanted it in cash. However, they explained to him that that wasn't the way it was set up and that his check would be coming in the mail in about thirty days. Well, Bo got upset with them and told them that if he couldn't get it now, he would take that ticket right back to the store in Crab Orchard and get his money back, which was $2.00.

BOYS, WHAT A RIDE

No punch line here, just a true story. Claude J. was hunting on Flat Mountain, close to the Merridian area, and he came upon a big buck sleeping in a hole where a large hickory tree had blown over. Claude was a brave man, but his elevator didn't go up to the top floor. He pulled out his hunting knife and jumped down on top of that buck to kill it, but that deer came out of that hole faster than you could blink

your eye and bolted down the side of that mountain with Claude holding on for dear life. The deer ran under a limb, which caught Claude under the neck and jerked him backward. He hit the ground pretty hard but was able to get up and get to the emergency room. When he saw some of his buddies, he told them, "I don't think I'll try that again. It's not good for a person's body."

GIVE ME SOME OF THAT GOOD RED-EYED GRAVY

This is an absolutely true story that happened to a couple of good friends of mine from Crab Orchard named Slick and Arkie. They went up to Whites Creek to work in the timber for a logging company and made some good money compared to what others were making back in the day. They boarded with an elderly couple for about $10.00 each per week. The lady was an excellent cook, and she always prepared some delicious meals for them when they came in from work.

One day, they sat down at the table, and she had biscuits and gravy, country ham, jelly, and all kinds of delicious breakfast items. While they were sitting around the table talking, Slick decided to stir up the ham and bacon bowl that the lady always placed in the warming closet on the old wood stove. Slick told me, and it was the truth, "When I stirred up the grease in the bottom of that bowl, if there was one fly in the bottom of that bowl, there had to be a million." Arkie and Slick packed up all their clothes and belongings and told the elderly couple that the job had played out, and they would be moving on. That red-eyed gravy wasn't so appealing after all.

LAST TRIP TO CRESTON

Some buddies of mine from Pumpkin Center were out running around in Estle's 1950 Oldsmobile Rocket, and one of them needed to go over to Creston to pick up something. So, we cut down the road between Dixon's and Hixon's store and took off down through there toward Creston. Estle was going way too fast, and I had a feeling we were going to run out of the road. Eventually, we came up on this curve, and we did run off the road. We cut down through the woods and ran straight into a big white oak. It jarred us pretty bad, but none of us seemed to be too badly hurt. We started walking back up to Highway 127, and this guy named Mack started complaining that his head was hurting really bad. In fact, he kept saying his forehead was hurting. When we got up to the light of the store, we could see where the word "Oldsmobile" was imprinted on his forehead from where he hit the dashboard.

ARE YOU GOING TO FISH OR TALK

Clyde B. loved to fish more than anybody I had ever seen, whether it was with or without a license, on anybody's property, or anywhere else. He wasn't afraid of the game warden or anyone else. One day, he went into Caruthers's Grocery Store to show off a nice string of bass he had caught at the Old City Lake and to buy a plug of Apple tobacco. He was bragging to the guy behind the counter about how he could catch any amount of fish anytime he wanted to, and it was so easy.

The man who was standing there listening to Clyde expressed his desire to go fishing with him someday. Clyde replied, "Sure, anytime." So, they set a time, and the man followed Clyde to the lake, and they went out in Clyde's boat. After a little while, Clyde opened up a bucket, pulled out a half stick of dynamite, lit the fuse, and threw it into the water. Four or five bass came to the surface. The man was

shocked and said, "You can't do that; it's against the law. Besides that, I'm a Tennessee State Game Warden, and I'm going to have to put you under arrest." Clyde reached into his bucket, pulled out another half stick of dynamite, lit the fuse, and handed it to the man, saying, "Are you going to fish or talk?"

HE HAD SCALES ON HIM

There was a man named Snooks who lived out past Potato Farm Road, and he happened to be my brother-in-law. He was a big cutup and liked to tell tall tales. One day, he was talking to a friend at Huddle House and told him a big fish story. Snooks said he had been fishing and that he caught a largemouth bass that weighed seven pounds and four ounces, but it got away. The friend asked Snooks, "If it got away, how did you know how much it weighed?" Snooks replied, "He had scales on him."

A LOVELY SONG ABOUT CRAB ORCHARD: THERE'S SOMETHING UP THERE IN THEM CRAB ORCHARD MOUNTAINS

(Verse 1)
There's something up there in them Crab Orchard mountains,
But, I can't say just exactly what it is.
But if you go up there in them Crab Orchard mountains,
If you shoot at that thing, you'd better not miss.

(Verse 2)
My cousin Agbert called and said, "Hey Gus, let's go a-hunting,"
So we climbed about a half a mile above the old lime vats.
We were sitting under Big Rock when we heard somebody holler,
"Lord, have mercy on my soul, what in the world is that?"

(Verse 3)
When we looked up, his feet were hanging halfway over Big Rock,
The feet and legs of a man were hanging out the side of his mouth.
We cut down off that mountain, running through crab apple bushes,
When we stopped and looked behind us, Agbert began to shout.

(Chorus)

What is that thing up there in them Crab Orchard mountains?
It looks to me like Big Foot and Sasquatch rolled into one.
If you're brave enough to go up there in them Crab Orchard mountains,
tains,
I'll tell you now, old partner, you'd better take a great big gun.

(Verse 4)
There's something up there in them Crab Orchard mountains,
But I can't say just exactly what it is.
But if you go up there in them Crab Orchard mountains,
If you shoot at that thing, you'd better not miss.

Words & Music By Jimmie Turner - 931-456-7592 or 931-248-3651
75 Willow St., Crossville, TN 38555 Jimorine@frontier.com

I'LL BE DOGGED IF IT AIN'T

There were two old country gentlemen who lived close to Crossville, and they loved to tell tall tales. Their names were Seth and Albert, and they often sat on Lyer's Bench at the Courthouse Square. If you wanted a good laugh, all you had to do was strike up a conversation with them. One day, I passed by and asked them what they were up to, and Seth told me they were looking for somebody who wasn't doing anything so they could join them. Seth got sick and had to be put in the hospital for a few days. When I visited him, he was ready to get out, and he said he had to go home and pay his "utensil bills." I said, "You mean utility bills," and he replied, "Yeah, that's what I meant to say, I just couldn't think of that word." Neither Seth nor Albert could tell time. Albert would ask Seth, "What time is it?" and Seth would pull out his pocket watch and show it to Albert, saying, "There it is." Then Albert would say, "I'll be dogged if it ain't."

THAT'S THE PART I LIKE

Bill and Sue retired from their jobs in Ohio and moved to Clarkrange, where they bought a beautiful house. When their friends came to visit, Sue wanted to show them their new home. Bill had been out clearing some land, and Sue didn't realize he had come back to the house and was taking a shower while she was in the garden. Sue showed her friends the kitchen, bedrooms, and the master bedroom, which had a lovely ceramic tile bathroom adjoining it. Then Sue said, "Now, here's the part I like," and she opened the bathroom door, revealing a surprised Bill in his boxer shorts while he was shaving. Sue's friend was embarrassed and ran out of the house, but Sue comforted her, and they all ended up laughing about it later. This is a true story, reminding us that embarrassing moments can happen unexpectedly.

LET'S GO SKIING

When Renegade Resort first opened, my cousin and I got a job running a snowmaking machine. We would cover the slope with snow throughout the night, which was a great experience. One night, some of our buddies from downtown Crab Orchard showed up, a bit intoxicated, and wanted to go skiing. We told them we weren't allowed to enter the ski rental area, but one of the boys, Frog, insisted that they wouldn't cause any harm and promised to put everything back as it was. So, we gave them the green light. None of them had ever been on skis before. We warned them it could be dangerous, but they either weren't afraid or simply didn't care.

Frog claimed he had been skiing in Gatlinburg for years, but we knew he was exaggerating. We suggested they start on the beginner's slope, but one of the guys confidently stated, "We ain't beginners." They put on their skis, and off they went. John fell early on and had trouble getting back up, so we helped him. Meanwhile, Frog and Flutter decided to tackle the main slope.

They were going at least forty miles per hour when Flutter suddenly left the ground and ended up in the top of a sorghum tree. Frog, on the other hand, wrapped himself around a sugar maple, tearing one ear halfway off, breaking his right arm, and bloodied his face. When we reached them, Frog said, "I told you all I was an experienced skier, but I won't be trying this again tonight."

WHAT IN THE WORLD IS THAT

Brother Raymond Lawson, a beloved preacher in Tennessee, was squirrel hunting near Pine Grove. He stood at the bottom of a high bluff, thinking he saw a squirrel in the top of a tree. He took a shot, but to his surprise, a sheep came tumbling down through the limbs. Raymond was shocked, but he knew who the sheep belonged to, so he went to the owner's house and offered to pay for the sheep. However, the owner refused to accept any payment, telling Brother Raymond not to worry about it. That's the way things used to be.

THE SWEET GRANDMOTHER

A sweet grandmother called Cumberland Medical Center to inquire about a patient's condition. The operator was polite and asked for the patient's name and room number, which was Norma Findley in room 302. The operator placed her on hold to check with the nurse's station. After a few minutes, she returned to the phone with good news. Norma Findley was doing well, with normal blood pressure and all blood work coming back normal. Her doctor even said she could go home tomorrow. The little grandmother replied, "Thank you so much." When the operator asked if Norma was her mother, the grandmother responded, "No, this is Norma Findley in room 302. Nobody tells me anything in here."

THE PERFECT MARRIAGE

A man and woman had been married for 60 years and shared everything except for one secret. The woman had a shoebox in the top of her closet that she had cautioned her husband never to look inside. When she fell seriously ill, she gave him permission to open it. Inside, he found two crocheted dolls and $95,000 in cash. He asked her about

the contents, and she explained that she crocheted dolls only when she was angry with him. He was pleased to learn there were only two dolls in the box, signifying that she had been angry with him only twice in 60 years. Curious about the money, he asked where it came from, and she replied, "That's the money I made from selling dolls."

THE BRAVEST MAN IN CRAB ORCHARD

Walking late at night from Crab Orchard to Bat Town was always a fearful endeavor due to the presence of wild animals like foxes, black panthers, rattlesnakes, and even two-legged creatures. There were rumors circulating about a big white creature that had been seen near Bat Town Road, and it was said to have growled at people who walked in the area after dark.

One night, a fellow named Cletus B., who wasn't known for his intelligence, got wind of the rumors and decided he would go and catch this mysterious creature. He had consumed some Tennessee Rot Gut Moonshine that night and believed he was ready to confront the monster that had everyone else terrified. With determination, he set off on his mission.

Cletus walked from Halley's Grove Lane to Bat Town Road, and as he stepped onto Bat Town Road, he encountered the creature. It approached him closely, and without hesitation, Cletus attacked it, attempting to wrestle it to the ground. However, the creature retaliated, turning around and biting off Cletus's left ear. He ended up in the emergency room at the Crossville hospital.

To his surprise, Cletus later discovered that the big white creature was nothing more than one of Vern Wheeler's large Yorkshire sows. After his recovery, he encountered some of his friends at Howard ShilTell's Store and admitted, "You all knew what that thing was in the first place, and you should be ashamed of yourselves."

ROOSTER WITH TWO LIVES

One evening, my dad went down to the barn to do some feeding and milk the cows. This big red rooster flogged him, so he kicked that rooster about ten feet, and it started flopping all over the place. Dad thought he had surely killed it. He took the rooster and threw him up on top of the shed so the other animals wouldn't eat him. Then he went up to the house and told my mom to put on a kettle of water and that he had killed that old rooster. They were going to pluck him and fry him for supper. But when dad went back down to the barnyard to get him, the rooster was standing on top of the shed, crowing, so dad left him alone.

THEM OLE HENHOUSE WAYS

This good old boy from Pine Knot, Kentucky, had moved down to Sunbright, Tennessee, and got to know a lot of people, and everybody liked him. He hung around the local hardware store all the time to stay away from his wife as much as he could because he was henpecked. She wouldn't let him go fishing or hunting, or do much of anything without getting permission from her. He told some boys down at the store that he thought she was part Indian and part bulldog because if she wasn't always on the warpath, she was lying on the couch growling about something. One day, a friend of mine named Larry saw Frank in the hardware store and asked him, "Frank, are you really henpecked like people say?" Frank answered him, "No, not me, but I sure do have them old henhouse ways."

TALKING ABOUT BEING HENPECKED

I am most definitely not henpecked, and I am certainly the head of my household. However, my wife is the neck that turns my head. I will say that I am the one who always gets the last word in, and it's, "Honey, can I come out of the closet now?" or "Honey, can I come out from under the bed for a while?" My wife loves me so much that she wrote a beautiful love song about me. It goes like this:

"Honey, you're the reason I can't sleep at night,
Honey, you're the reason I hang my head and cry,
Honey, you're the reason my poodle's name is Pudgy,
Honey, you're the reason our kids are ugly."

WILD DREAMS

Joe from over in Bat Town has always had bad, sometimes very crazy dreams, but he recently told about some that beat anything I'd ever heard. He told me that the other night he had a dream in which he was locked up in a muffler & tailpipe shop and couldn't get out to save his life. He woke up totally exhausted. Then he told me he had another one where he dreamed he swallowed a marshmallow as big around as a beach ball. When he woke up, his pillow was missing.

I LOVE THAT COLOR

E. Eugene S. was kind of a bully from Hebbertsburg, and a few years ago, they still rode horses to Crossville. I remember very well that I was standing by the Palace Theater one night, and two old boys came riding up Main Street on their horses. When they got even with me, I barked like a dog, and one of the horses jumped and almost threw the fellow off. He looked at me and said, "Hey, don't be barking at my horse like that; you almost got me thrown off." I told him, "It wasn't me; it was that little dog that ran right down through here" (a little

alley ran down the side of the Palace at that time). The man cussed out and then rode out of town.

Back to E. Eugene S. He rode to town and went into the Town Tavern, tying his horse up outside. When he went back out to go home, his horse was completely painted green. He got mad and went back into the bar, shouting, "I want to know who the crazy devil was that painted my horse." The meanest, biggest guy he'd ever seen stood up and said, "I did; do you want to do something about it?" E. Eugene said, "I just wanted to let you know that the paint is dry and it's ready for another coat."

PASTORS HAVE TO DO EVERYTHING

You can get some of the strangest requests you could ever imagine as a pastor, such as helping find their cats or visiting somebody who does not want to be visited and will slam the door in your face. But this one request was the strangest ever. A knock came on this pastor's friend's door, and when he opened the door and asked, "Can I help you?", this man said, "Yes, I want you to give me a good whipping, and I mean, wear me out." Pastor Jim said, "Why, I can't do that; I could go to jail for doing something like that." The man insisted and told the pastor he had been mean to his family and had not loved his son like he should have and told him just how mean he had been, and so on. Then Pastor Jim said, "Is this some kind of joke, or are you serious?", and the man said, "Yes, I'm serious, and I want you to do it now." Pastor Jim said, "Well, come on in," so the man came in, and Brother Jim took his belt off and told the guy to bend over, so he wore him out with his belt. When he got through whipping the man, the fellow said, "Thanks a lot; I feel much better now." Pastor Jim never saw nor heard from the man again. True Story.

SHE COULD NOT GIVE IT AWAY

We had a pretty good refrigerator, but we'd had it a long time, and we decided it was time to get a new one. So my wife told me that we should set it down by the road and put a sign on it that said "Free," so we did. Of course, I put a rope around it to make sure no kid could get into it. That thing sat there for about two weeks, and not one person even stopped to look at it. My wife suggested that I put a sign on it that says, "Refrigerator $50.00," so I did, and the next day, a man stopped and bought it. That goes to show that people do not want something for nothing.

A FEW NAMES OF PEOPLE FROM CRAB ORCHARD

Delmont, Orville, Lee, Amberly, Elsy, Erinol, Dunny, Dorell, Trigger, Delli Mae, Linda Sue, Claudine, Chrystal Mae, Marsha Mae, Elly May, Darcy Mae, Geritie Mae, Destiny, Jazlean, Bobbi Joe, Blue Bonnet, Scatter, Dakota, Cal, Quintan, Homer, Shirlene, Enos, Luther, Moose, Lester, Sharlexia, Harley, Jessis, Birdseye, Silas, Barney, Betty Lou, Bubba, Eustice, Shayna, Zek, Winchester, Zebby, Lenn, Dinky, Clifton, Barf, Jeb, Cleavon, Billy Bob, Buckley, Emmitt, Gretchen, Virgil, Maddy, Lideanie, Randy Leigh, Flossy, Bodean, Augustus, Buck, Cletus, Buford, Cooter, Garth, Georganna, Josephine, Magnolia, Rhett, Roscoe, Rufus, Saggory, Wilbur, Sheridan, Zadie, Walker, and Yates. There ain't a thing wrong with any of these names because they are all beautiful, for I have one of them.

SOME CRAB ORCHARD RIDDLES

How did the old boy die from drinking milk? The cow fell on him.
What do you have when you get twenty folks from Crab Orchard in the same room? Answer: A full set of teeth.
How do you tell if somebody from Crab Orchard is married? Answer: There's chewing tobacco stains on both sides of his truck.
What does a beer bottle and a man from Crab Orchard have in common? Answer: They are both empty from the neck up.
What does an old boy say to his dishwasher when it quits working? Answer: Get back in there and get those dishes done.
What is the difference between a zoo in Crab Orchard and any other zoo? A zoo in Crab Orchard has a description of the animal on the cage door, along with a recipe.

THE BAPTIST BATHROOM

This very proper lady began planning a week-long camping trip for the adult group at the Baptist church that this gentleman attended. She wrote and told the manager at the campground that they were coming and to be sure that their camp would be equipped with modern facilities. She could not bring herself to write the word "toilet" in a letter, so she wrote the old-fashioned term "Bathroom Commode." Then she decided that did not look good either, so she used the abbreviation "BC."

When the man got the letter, he was confused about what the "BC" could possibly mean. He questioned some of the campground employees, so they narrowed it down to Baptist Church, since the letter was written on Baptist Church letterhead. After the manager had it all figured out, he wrote the lady a letter in response which said, "The BC is located nine miles from the campground in a beautiful grove of trees. I admit it is quite a distance if you are in the habit of going on a regular

basis. No doubt you will be pleased to know it will seat about 350 people at one time. It is opened on Tuesday, Thursday, and Sunday of each week, and some people like to take their lunch and make a day of it. The acoustics are very good, so everyone can hear the quietest of passages. We are having a fundraiser to purchase new seats, since the old ones have holes in them. It may interest you to know that my daughter met her husband there. Unfortunately, my wife has been ill and has not been able to attend regularly, so it has been six months since she last went. It pains her very much not to be able to go more often. As we grow older, it seems to be more of an effort to go, especially in cold weather. Perhaps I can accompany you there the first time you go and sit by you, so I can introduce you to all the other folks that will be there. I look forward to your visit, as we offer you our friendly services."

JOHN ACTED UP IN CHURCH

John was sitting in church beside his mom and dad one day, and the pastor was beginning his message. So, Brother Bill started out by saying, "What shall we do with sin?" and then he said it again with more force, "I said, what shall we do with sin?" John thought, "If he says that again, I'm going to answer him." Then the preacher went again with all the force and loudness he could muster up as he drew back and came across that pulpit like a bulldog, hollering one more time, "I said, what are we going to do with sin?"

Well, John, who was about twelve years old, stood up and with a Barney Fife voice, hollered out, "Pastor, I think we've got to nip it in the bud." Bill told me that his daddy got a hold of his overall galluses and jerked him down on a pine knot on that old wooded bench, then flipped him on the back of the head with his big middle finger. His momma got a hold of the hang-me-down part of his arm and pinched him and twisted it. He said all that hurt him so bad that he had a vision

and saw stars the rest of that day but also said that he didn't act up in church again.

THEM BOYS WERE MEAN

When my wife and I pastored in Fertigs, Pennsylvania, one Sunday morning while I was preaching, two big old boys about 15 or 16 years old got into a fistfight. By the time I got back to them, they were all locked up with an arm hold on the floor between the pews. I just walked back to where they were fighting and looked down, and they looked up at me. I said, "What in the world is wrong with you two?" Then I told them to get up off the floor and sit down, so they did.

This church was known as "The Church in The Wilderness," but as it turned out over a few years, it became a great church. One morning while I was preaching, a woman came out of a deep sleep and took one of the hymnals. She went across the aisle and hit her son in the head with it, and he said, "Mom, what did I do?" She had just woken up and must have been dreaming that George was acting up.

THE MOST BEAUTIFUL LOVE SONG EVER WRITTEN
"LIKE I SAID"

The hair under your arms is long and stringy,
It's longer than the hair upon your head,
And lately, you've been so cold and cranky,
Your nose is a crimson crooked red.

Your eyes always look at one another,
The tears run down your back you shed,
You're the spitting image of your mother,
Oh, but I still love you like I said.

Like I said the day we tied the knot, dear,
That I would always make sure that you're fed,
And lately, I cannot reach around you,
Oh, but I still love you like I said.

Your lips are parched and browned by snuff juice,
But, dear, you've got a level head,
It runs out both sides of your mouth evenly,
You steal your snuff from Uncle Fred.

Your teeth glow in the dark on the nightstand,
Your wooden eye comes out when you go to bed,
Your breath smells just like rot-gut moonshine,
Oh, but I still love you like I said.

THE BAPTIST DOG

This Baptist pastor and his wife wanted to get a dog, but he had to be just like them in every way. He had to believe in the King James Version just like them and every single thing just like them. So, they searched and searched at every kennel in town. Finally, one day, they thought they had found the perfect Baptist dog, and the manager of the kennel assured them that old Bowser would be the one.

The pastor took the route home with them and called some of their members over to watch him work. The pastor said, "Bowser, find Psalms 23." So he took his paws and started flipping pages until he stopped right on Psalms 23. Then the pastor said, "Bowser, find John 3:16," so old Bowser started flipping through the pages again and stopped right on John 3:16.

One of their members said, "That is great, but does Bowser do any kind of special dog tricks?" The pastor said, "He sure does," and then he said, "Heel, Bowser," so Bowser ran into the kitchen and dipped his

right paw in a can of Crisco and then ran and jumped up on a chair and placed his paw upon the pastor's forehead and started howling. The pastor said, "Oh, my Lord, He's Pentecostal."

THAT'S A FAST CHICKEN

My brother Gene was driving down Brewer Road, which is in the Vanderver area, when he noticed this chicken was running alongside his car. He was doing about 45, but pushed it up to about 55, and the chicken stayed right with him. He saw a farmer standing by a barn and stopped and asked the man if that was his chicken and if he knew it could run that fast. Then Gene noticed the hen had three legs. The farmer said, "Well, my wife and I have a son, and all three of us love the drumsticks when we fry a chicken, so me and this biologist out of Knoxville came up with this three-legged chicken, and now they're running around here everywhere."

Gene asked the farmer, "Well, how do they taste?" The farmer answered him, "Well, we don't know, we've never been able to catch one of them."

THE GRAVESIDE SERVICE

As a young minister from Crab Orchard, I did not know very much about funeral services and weddings, but you learn a lot only through experience. So I certainly did over the years. One day, this funeral director from Wartburg, Tennessee, called me, told me about this man dying, and desired only to have a short graveside service. He asked me if I'd be willing to do it. Of course, I said I'd be glad to. He told me what time it would be the next day and gave me the directions on how to get there.

The next day, my associate and I went out to find this place. We drove around on these back roads for a while and couldn't find any cemetery. So, I knew we were running late, but we tried this one side road, and there it was. We saw two men with a backhoe already to cover the grave up. So we pulled in, jumped out of the car, and ran down to the gravesite. I told the men that I was sorry we were late and that we kinda got lost. They stopped and looked at us. I prayed and then did a short message. Then I had my associate pastor close the service in prayer. We told the men with the backhoe to have a good day.

As we started up to the car, I heard one of the men say, "I've been putting in these septic tanks for thirty years, and I ain't never seen anything like that."

HE'S A LONG WAY FROM HERE NOW!

This good ole boy named Dennis R. was out in his front yard one day along with his wife, and they were working around making it look beautiful all around the house as they always did. While working, a big buzzard flew over and did a number right on top of Dennis's head. He hollered to his wife, "Lucy, go in there and get me a paper towel right quick." She said to Dennis, "What for? That thing's already a half a mile from here now."

WORLD FAMOUS POTATO ROAD

This is a true story, but it is a little hard to believe. My brother Walt Turner, his wife Maria, and my brother-in-law Snooks took a trip to Houston, Texas to visit Walt & Maria's daughter who lives there. First of all, Snooks and Joyce didn't own a suitcase, so Joyce packed their clothes in a clothes basket and checked into a big fancy motel carrying their stuff in like that. What is so strange about this story is they went to what was supposed to be the world's largest flea market, and there were hundreds of booths and thousands of people.

Snooks found something he just had to have, so he was trying to get this woman's price down when she asked him, "Where are you from anyway?" Snooks answered her, "I live up there on the Potato Farm Road." The lady responded, "I know right where that's at, it's right up there close to Crossville, Tennessee." They were all very surprised.

GET ME TO HOSPITAL

This evangelist was preaching a revival over at Grievers Chapel Baptist Church in Ozone. The pastor warned him about a man he had in his church who had a tendency to go to sleep and snore really loud. The

evangelist told the pastor not to worry about it, and if it happened, he knew how to take care of it.

Everything went really well for the first couple of nights, but on the third night, there he went sound asleep and was snoring loudly as he was sawing logs. The evangelist just kept right on preaching. He went back to where the man was snoring with his mouth wide open and poured just a drop or two of quinine in his mouth.

The man woke up and yelled as loudly as he could, "Get me to the hospital; I think my gallbladder has busted."

COME BACK HERE

Dinkus, who lived in a community named Isoline, was a friendly fellow who liked to try out anything new that came out. He bought one of those new dog collars that were supposed to keep your dog from leaving the yard. He wasn't convinced it would work, so he got one of his good neighbors, Bill, to come over and help him try it out.

He had Bill put the collar around his neck and walk toward a barn about a quarter of a mile away, across a couple of fields. He told Bill that when he raised his arm, he should push the button on the collar. Bill started walking, and every time Bill stopped as instructed, a small electrical current in the machine jerked Dinkus's arm back up. This went on for over a mile until Bill finally got out of the range of the remote.

Bill took off the collar and walked back up to Dinkus's house, saying, "I'd be taking this thing back."

THE CHURCH GOSSIP

Just about every local church has a busybody or church gossip, placed there by the devil to be a thorn in the pastor's flesh. Mildred was the one in this particular local church in Crossville, and she was always sticking her nose into someone else's business. There was a good man named George who attended the church and worked as an electrician. The owner of a local bar hired George to do some work for him in the bar, so George did.

He parked his service truck right in front of the bar, so his tools and materials would be handy. Mildred passed by, saw George's truck, and started spreading rumors all over town. She claimed that she saw this man's truck in front of the bar and that one could only imagine what he was doing in there.

George found out about the rumors but didn't say a word. Instead, he parked his truck right in front of Mildred's house that night. What goes around comes around.

BETWEEN THE AXLES

Years ago, I worked for Starvin Marvin's Mobile Home Sales near the Bowling Alley, and I handled most of their service work. We had good friends there, and we all did well for a long time, but anyone can have a complaint once in a while. We certainly did one day.

What had happened was that a woman had bought a nice mobile home from the company, and a water leak had developed around the bottom of one of the commodes. I went out and put a new seal under it, thinking I had fixed it. However, we received more calls from her, and we attempted to fix it each time by putting a better seal on it. But apparently, there was more to it than just a seal.

One morning, she stormed into the office, very upset, and said, "You all didn't get that commode fixed, and now I'm in big trouble." The owner said, "Hold on a minute; I'm sure we can get all this worked

out." She replied, "Yeah, you wouldn't be saying 'Hold On A Minute' if you had seen me sitting out there between them axles a while ago." The leak had caused the whole floor to give way, and she and the commode had fallen through to the ground.

A CHICKEN NECK SAVED THEM

This pastor friend of mine and his wife fell on hard times while pastoring a small church. They got down to nothing for a short time, but they made it through until things got better. The pastor's wife decided to defrost the refrigerator and found a chicken neck under the ice. She decided to boil it.

While boiling the chicken neck, a woman knocked on their door. When the pastor's wife opened the door, the woman handed her a dollar and said, "The Lord told me to bring you this." She turned and walked away. The pastor's wife went to the store, bought a can of biscuits, made some dumplings, and put them into the chicken broth. They had chicken and dumplings for supper.

The next day, their overseer made sure they had plenty of food. We may get down to nothing, but we need to remember that Jesus IS the Master of Nothing, and He can turn nothing into something.

YOU'VE GOT THE WRONG SEAT

Funny things do happen in church sometimes, and it happened to my wife and me. We were pastoring a wonderful group of people in the state of Pennsylvania, and a great man named Tom O. was our Sunday School Superintendent. He was up front, boosting our Sunday School, and when he finished, he turned the service over to me and went back to sit down.

Here's what happened: my wife was sitting right in front of Tom's wife. Instead of Tom sitting down by his wife, Bell, he sat down by my

wife, Morine. He even put his arm up behind her on the pew and turned to say something to her. When he realized his mistake, he jumped up and said, "Oh!" Then he quickly sat down by his own wife, but it was too late, for everyone behind them had seen what had happened, and they all had a good laugh.

REVELATION OF A HOG FARM

One time, a pastor friend of mine called me and told me that he and his family had just moved into town and were looking for a church. He asked me about our church's teachings, and I took the time to explain all of our beliefs and doctrines. After I finished, he said, "Thanks a lot, Bro. Turner, you did a good job." I asked, "Who is this?" He replied, "Your friend, Brother Wallen." I thought, "Ole Buddy, I'll get you someday." We often exchanged playful banter.

One day, I had to call Bro. Wallen for some business, and when he answered the phone, I thought, "Just say something silly, anything." So, when he answered, I said, "Brother Wallen, this is Sister Johnson. I went out to feed my hogs, and one of them bit me. I'm bleeding like a stuck hog, and I need you to come pray for me." He responded, "I'll be right out there; try to stop the bleeding." Then, I realized he was serious, so I quickly said, "Bro. Wallen, this is Bro. Turner." He replied, "Oh, Brother Turner, I have a woman in my church named Sister Johnson who owns a hog farm, and you had me scared half to death." I learned not to take my joking too far.

A SONG ABOUT THE CUMBERLAND PLATEAU
UPON THE PLATEAU IN TENNESSEE

Upon the Plateau in Tennessee, these good ole boys got after me
They chased me down through Hebbertsburg, I took a left, they
straightened out this curve
They ended up in this man's living room, he came out on them with a
sawed-off broom
He said, "Alright, boys, cut them headlights out before you wake up
everybody in the house"

Strange things happen upon the Plateau, I was raised right here by my
ma and my pa
Along with twelve kids out on the farm, raising cane and selling corn
We were a little crazy, but not insane, some people said that we were
strange
One thing I can say is that we were free, upon the Plateau in Tennessee

Upon the Plateau in Tennessee, one day a strange thing happened to
me
I took a shortcut over through Bat Town, it was nothing but a circle
going round and round
I ran into the back of my car, trying to find my way out of there
I came upon this moonshine still, I got out, but I was almost killed

Upon the Plateau in Tennessee, beats anything that ever could be
When Grandpa saw his first automobile, coming toward his house
upon the hill
He said to Granny, "Go and get my gun," he shot that car, the man
jumped out in a run
Granny hollered, "Did you kill it, tell me the truth?" he said, "I don't
know, but it turned that man loose"

Words & Music By: Jimmie Turner 75 Willow St. Crossville, TN 38555 Phone: 931-456-7592 or 931-248-3651 Email: jimorine@fronntier.com

THE PASTOR NAMED DONALD DUCK

This young Christian man, named John, was a fine young man and a great friend who came up under my ministry. He was called out by the Pennsylvania State Overseer to pastor this church in the Eastern part of the state. Being a lay minister, or someone who is just starting out in the Pastoral Ministry, he was not yet able to conduct wedding ceremonies without getting written permission from the General Overseer of the Church.

This young couple in his church asked John to marry them, so he wrote a letter to the General Overseer to get his approval. The General Overseer decided to call Brother John to give him the go-ahead. It's unusual for a lay minister to get a phone call from the General Overseer, but John did.

When the phone rang and John answered, a man said, "This is your General Overseer, Brother MA Tomlinson." John replied, "Yes, Sir, and this is Donald Duck." Then Brother Tomlinson said, "I realize that you don't normally get a call from me, but this is your General Overseer." John responded, "Yes, Sir, and this really is Donald Duck." So Brother Tomlinson said, "Well, Donald Duck, when you see Brother John, tell him I said it's alright for him to go ahead and do the wedding ceremony for those young folks in his church." John tried to apologize and was totally embarrassed, but Brother Tomlinson just chuckled a little and told John that everything was fine.

LAUNDROMAT IN THE WOODS

My cousin Randal took his dad, Carl, deer hunting out in the Catoosa Wildlife Area. He told him to dress warmly because it was going to get cold. So Carl put on about seven layers of clothes. Randal had his

dad sit up on this bank next to a creek while he went deeper into the woods.

Well, nature called, so Carl started stripping off clothes and hanging them on bushes all around. After a while, Randal thought he'd go check on his dad, but he got a little turned around. He asked a fellow hunter if he'd seen another hunter. The man told Randal, "I don't know if he was a hunter or not, but I did see a man doing his laundry in the creek; he had clothes hanging everywhere."

HE JUST FOLLOWED HIM HOME

My brother Charley was always a big cut-up and loved to laugh and make people laugh. We lived on Doctor Nevils's farm, and we always had some big times there. One Christmas Eve, all of us kids hung our stockings up behind the warm morning stove. Charley hung up a five-gallon lard can. He got the same thing we all got, which was an apple, an orange, some candy, and nuts.

One night Charley went to town to shoot some pool, and when he started home, one of his buddies decided to come home with him and spend the night. When they got to the farm, Charley took this old boy into a shed where the girls had a playhouse.

Charley crawled into an old cot and told ole Howard to be quiet so they wouldn't wake up Mom and Dad. Howard asked Charley, "Does your mom and dad really live in here?" Charley told him they were in the next room.

When Charley thought his buddy was asleep, he eased up and cut out for the house as fast as he could go. But Howard was right behind him. Charley got to his bedroom window, opened it, and gave Howard a boost up into the room. He then slammed the window down and took off running. But the old boy dived out the window and followed him.

Finally, they got settled in and went through the front door to the bedroom and went to sleep.

WHAT ARE ALL THESE 15¢ CHARGES FOR?

When we lived on Doctor Nevils's Farm, my Dad Walter had a charge account at Earl Caruthers's Grocery Store. Back at that time, my mom and dad would buy quite a few things there on credit. I ran around with Tom and Owen when we were about ten or eleven, so I got into the habit of chewing tobacco at a very young age. I would go into Earl's store and tell him that my Dad needed a plug of Days Work, and I did this quite often, so me and my buddies would chew it.

One night, my dad got all his bills out and was getting ready to go down and pay his account off as he did every month. He asked my mom, "What are all these things we've been buying that cost 15¢?" She said she didn't know. So Dad took all his bills into the store and asked Earl what all these items were. Earl told Dad, "That's where your boy comes and gets your chewing tobacco." Dad said, "That's funny, I don't even chew."

LET'S GET OUTTA HERE

My friend Roy from Dorton is a good ol' boy but is just a little bit off in some ways, but is a good electrician. I used to help him wire houses. He had an old, worn-out 1961 Chevy Van, which was just about worn out and smoked so badly that I was almost ashamed to get in it, but I did. One day he needed some material from Crossville Cash Home Center. They had us go around back to pick it up. We did, but we had to stop at this little building to let the men in it check our material list. Everything was fine.

Roy pulled up so that the tailpipe on the van was even with the door of the little checkout place and stopped. He said, "Watch this," and then he floored the gas pedal, filling that building with smoke. The two guys started running out, gasping for breath, hollering, and threatening Roy. I yelled, "Let's get out of here before those boys whop us." Roy said, "Ah, they'll be alright."

LET'S GO ICE FISHING

Don and Earl from downtown Crab Orchard fished all the time in Daddy's Creek and Orbend River, plus in the lakes around the Crossville area, but they had never been ice fishing. One day they decided to go, so they drove up above Pontiac, Michigan. They stopped at a sporting goods store and bought six ice picks. After a few hours, they came back and bought twelve more. A few hours later, they returned and purchased every ice pick the man had.

The man got curious and asked Don and Earl if they were doing any good on their first ice fishing trip. Earl replied, "Why no, we've not even been able to get our boat in the water yet."

PHONE CALL FROM HEADQUARTERS

My family and I were appointed to a church in Pennsylvania known across the state as The Church In The Wilderness, because it was way back at 40th & Plum, which is forty miles from town and far back in the sticks. We tried to borrow money from many banks in the area of Franklin and Oil City, but no one would even talk to us about it until an oil drilling company struck oil on our property. Then everything changed.

We were in the process of building a new church. One day, while I was over at the new sanctuary, my daughter Tina ran over and told me that

M.T. Lincus was on the phone and wanted to talk to me. I figured it was something about the oil wells, so I ran over and grabbed the phone and said, "Hello Brother Lincus, how can I help you, Brother?"

The man on the phone said, "Brother Turner, could you pick me up at the Franklin airport in the morning? I need to come up there and pay you a visit." Now, Brother Lincus was the Field Secretary to the General Overseer, so I said, "I sure can, but would you mind telling me the purpose of your visit?" The man said, "Well, we hear you've been chewing tobacco, and we are going to have to pull your license." I knew then it was some kind of joke, so I said, "Why, Brother Lincus, I quit chewing tobacco over six months ago." Then the man on the phone started laughing and said, "Brother Turner, this is Brother Ron Roudebush," who happened to be one of my best friends.

EMPTY HEADED

Mr. Swan, my eighth-grade school teacher, was a very good teacher and a very good man. But one day, he asked the wrong question. He asked the whole class, "Now, I think you all would agree that if I stood on my head for just a few minutes, all the blood would rush to my head, and my face would turn red," and everyone answered in agreement. Then he asked, "So if all the blood would run to my head while I'm standing on my head, why will it not do it when I'm standing on my feet?" One of his very smartest students, from Crab Orchard, of course, said, "Because your feet are not empty."

MORE ADVENTURES ON DOCTOR NEVILS' FARM

I have great memories from living on Doctor Nevil's farm, and I felt that people who once had good country living, or still do, would love stories like these. Every year, my dad would make molasses, and I would feed the cane mill with the stripped-off cane stalks. I would even peel the outside off and chew them to get the sweet juice out of them. The juice would run from the mill down to a big vat where it would boil all day, and then it would be put into gallon buckets. Mom and the girls would make molasses candy, and it was so good. We'd have it for supper along with gravy, biscuits, and fried potatoes.

One night, Mom was cooking supper and making gravy when my brother Charley poured a whole bottle of green food coloring into the gravy. Mom got angry with Charles and told him, "Now, you've ruined it, and we won't be able to eat a bite of that." However, Mom put it out on the table anyway, and we all ate it like it was going out of style.

Right before Easter one year, my mom had put about five dozen eggs into a huge oatmeal box and sat them on top of the warming closet on the old wood cook stove. I accidentally knocked them off onto the

floor, and it broke every single egg. I tried to wipe them up and then picked up the shells and threw them outside. I then tried to mop the floor, and it was a yellow mess. When Mom and Dad got in from town, I was hiding, thinking for sure one of them would scold me. However, I heard them laughing at the pretty floor, so they did not punish me that time, but just said, "We've got plenty more."

I remember very well that the only thing Dad had ever driven was a Farmall Tractor. He bought a 1936 Ford at Fox Motor Company in Crossville for $100 and learned to drive it across the big fields on the farm. Finally, he got his license and started driving to town and back. One day, the car would not start because it was cold, so we tried pushing it toward the barn, and it still didn't start. We left it sitting there. A bunch of neighborhood kids was playing around the barn. My sister Faye got in the car, and we started pushing it down the lane. I yelled to her to flip the little switch up and let out the clutch, and she did. The car started and tore down about fifty feet of fence.

GET DOWN HERE QUICKLY

Willard called the fire department and said, "Get down here quickly, my barn is on fire." The fireman asked him, "How do we get there?" Willard said, "Don't you all still have them little Red Trucks?"

BE SURE TO GET FLOWERS

This boy named Billy Bob went to the hospital to visit his grandma and came home with a bouquet of flowers. His dad thought it was kinda strange, so he asked his son, Billy, "Where did you get the flowers?" Billy replied, "You told me before I went to see granny to be sure and take the flowers, so when she wasn't looking, I got them."

THE ANSWER IS IN THE BIBLE

A man went to his pastor and told him that he was in all kinds of financial trouble, about to lose his house, car, and everything he owned. The pastor told him to go home, randomly open his Bible, close his eyes, and put his finger on a spot. When he opened his eyes, he would see his answer. So he did just that, and when he opened his eyes, his finger was right on "Chapter 11."

DON'T GET SMART

A city slicker came up through Crab Orchard on US Highway 70 and asked an old boy if he could tell him how to find the courthouse. He pulled over and said, "Hey, Bud, can you tell me how to find the County Courthouse?" Bud answered him, "How did you know my name is Bud?" The city slicker said, "I guessed," so Bud replied, "Then guess where the 'come house is."

BANG, THERE SHE GOES

An old boy from Creston had been in the Army but finally got to come home. While in the military, he picked up an old hand grenade and wondered if it would still work. His mom and dad had plumbing put in their house while he was gone, so he decided to try the grenade on their old outhouse. He went down to it, pulled the pin, and tossed the grenade over to the outhouse, blowing it to pieces. His grandpa crawled out of the rubble and said, "Boy, it's a good thing I didn't do that in the house."

HE RAN INTO TROUBLE

Glen and his wife Virginia were driving down the highway when they got pulled over by a Tennessee State trooper. When the trooper came up to Glen's window, he told Glen, "You were speeding." Glen said, "No, I was not speeding." The officer said, "Yes, you were, I was right behind you, and you were doing 85 in a 45-mile zone." Glen replied, "No, I was not speeding." The trooper said, "Well, let me talk to your wife." So he said to her, "Just tell me the truth, 'Your husband was speeding, wasn't he?" His wife, whose name was Virginia, said, "I learned a long time ago not to talk to Glen while he's drinking."

GET OUT OF THE WAY

Flute G. loved antiques, so he visited one in Lebanon, Tennessee, and purchased for himself a beautiful Grandfather Clock. He was carrying it down the sidewalk to put it into the back of his pickup. A drunk man came out of a bar and ran right into Flute, knocking the clock out of his hand. The glass front shattered when it hit the sidewalk. Flute got very angry and said to the drunk, "Look what you have done, you have destroyed this beautiful clock that I just bought ten minutes ago." The drunk man replied, "Why don't you wear a regular-sized watch like the rest of us."

GET UM AT 4:00 IN THE MORNING

A good friend of mine named Roy M. from the Dorton Community is a really good fellow, but he's a little nutty at times. We went to the grocery store together to pick up a few things. After we checked out, Roy told the girl at the register that he wanted to pay for his and my stuff and asked her if she would run it all back through. The girl said, "You've got to be kidding me." Then Roy said, "Yes, I am." He looked over by the door and then turned around behind us and told everybody in line, "I want you to look at that, every time those people get close to that door, it opens by itself, now how does it know to do that?" A man behind us asked, "Where are you fellows from?" So I said, "Crab Orchard," the man said, "OH."

One night after church, Roy, my son-in-law Wes, and I went to Kroger to pick up some doughnuts, but when we got over to the counter where they were always at, it was empty. Roy asked the girl behind the counter where all the doughnuts were. She told him that the lady who makes them will not be in until 4:00 in the morning. So, it was only about 8:30 at night. Roy leaned up against the counter and said, "we'll just wait." The girl mopped a few minutes and then came back over to Roy and said, "Sir, you misunderstood me, I said the lady who makes the doughnuts will not be in until 4:00 in the morning." Then Roy said, "Oh, yes, I understood clearly, we'll just wait" and kept waiting. Wesley got real frustrated at Roy and cut down the aisle as fast as he could walk and hollered, "Men, what in the world is wrong with him."

OOPS, WATCH IT BOYS

We were having a District Convention in Manchester, Tennessee, and the church was packed. About ten ministers were sitting out on the back of the stage in folding chairs, for each one of them had a little part in the program. It was a makeshift stage because of some remodeling

the pastor and folks there were undergoing. The stage had a big curtain behind it, and the chairs were only about six inches from the edge. The local pastor had warned the ministers not to scoot back because they were not far from the edge. The stage was about two feet off the main floor, so sure enough, one minister scooted his chair back and there he went, pulling three more off with him. Nobody got hurt, but it sure hurt their pride.

MAN, IT'S SLICK OUT HERE

When we lived in Pontiac, Michigan, Roy and Faye Meadows lived up there too. Roy worked at the Ford Motor Company in Detroit, and I worked at Pontiac Motors, and we were doing pretty well at the time. We were going around to different churches singing and preaching, and sometimes we would go to each other's homes after church for snacks. One night, we were following Roy and Faye over to their house to have some food and fellowship, and the road they lived on was solid ice. When we turned onto their road, a car turned in behind me. So Roy began to show off, sliding sideways and then the other way. We were all just laughing at his antics. Of course, we were only going about ten miles per hour. Finally, we pulled into Roy and Faye's driveway, and this car pulled in behind us. It was the Michigan State Police.

The officer didn't even stop at my window but went straight up to Roy's window and said to Roy, "What in the world is wrong with you?" Roy responded, "Man, it's slick out here." So the State Policeman said, "It's not that slick, you're going to get your wife and kids hurt or killed acting like that." He didn't give Roy a ticket but came back to me and asked me how long I had been in the state of Michigan. I told him about a year and a half, and then he wrote me a ticket for about 60.00. Roy has never let me live that down.

I PILOT MY YACHT

My wife and I went over to the mall in Knoxville one day, and we had walked for a long time, so I got tired and sat down on one of those benches in the corridor while my wife continued shopping. This dignified-looking gentleman came over and sat down by me. I overheard him talking on his cell phone about having to go and file a flight plan. So after he got off the phone, I thought it would be good to strike up a conversation with him. I asked him if he was a pilot, and he told me he was. He explained that he and his wife were getting ready to fly down to Jacksonville, and so on and so forth. He then asked me if I was a pilot, and I told him I had a big boat, or that's what my kids call it. He didn't seem to see any humor in that and got up and said, "Have a good day," and walked off.

YOU GOT THAT SEAT BELT ON

I was driving from Crossville to Crab Orchard on Interstate 40, doing just a little over the speed limit when I saw this Tennessee Highway Patrol car coming up behind me with its blue light on. I thought, well, he couldn't be after me since I'm not doing but about 80 in a 75 zone, but I jerked my seatbelt on as fast as I could. To my surprise, he was after me. I pulled over, and he pulled right in behind me, and came up to my window. He told me he needed to see proof of insurance, registration, and my Tennessee driver's license. I complied and showed him all the documents. After checking them, he said he would only give me a warning this time and told me to be sure and keep within the speed limit. I assured him I would. Then he looked in the window and said, "By the way, Mr. Turner, do you have your seatbelt on?" I replied, "Yes, Sir, I sure do." Then he said, "Do you always run it through the steering wheel like that?"

THIS GUY IS NUTS

You run into all kinds of nutcases in the ministry, or I guess I could say they just have a great sense of humor, but I'd much rather see somebody laugh than to think they've been baptized in pickle juice. We had this evangelist come to our church, and, of course, he stayed with us. We took him to a restaurant, and the waitress overheard us talking. She asked a guy named Wayne where he was from, and he said, "LA," and she asked if he meant Los Angeles. Wayne replied, "No, lower Alabama." This guy had a spoon handle in his coat pocket that he had broken off a teaspoon and had burnt the end with a little torch. While the waitress came over to give us a refill, Wayne was stirring his coffee with this spoon handle. When she started to pour coffee into his cup, he pulled the spoon handle out of his coffee and said, "Look what this coffee has done to this spoon." The girl cried out loud, "Oh my Lord, it has eaten into it!" So Wayne showed her it was only a trick.

THAT'S JUST NOT THE WAY YOU GO ABOUT IT

This goofball went to the doctor and told him he just wasn't feeling well. When the doctor examined him, he found that the man had a green bean in his left ear, a piece of cauliflower in his right ear, and a piece of carrot in his right nostril. The doctor said to the man, "I can tell you why you're not feeling good; you're just not eating right."

IT'S NOT TIME YET

This couple lived way down toward the end of Lantana Road, and they were expecting a child. So, the husband walked into the house, and the wife said, "It's time." The guy picked up the phone and called his neighbor, saying, "Get over here right away and bring me some towels and some soap and help me fill a bucket up with warm water." The neighbor said, "Is your wife going to have the baby at home?" The husband replied, "No, but I need you to help me wash my pickup so I can take her to the hospital."

YEAH, IT'LL WORK

A man was driving down a country road and he ran out of gas. He stopped at the home of an older couple and told them he had run out of gas. He asked them if they could help him get a little bit of gas so he could make it to a gas station. The old man said sure and that he would siphon some gas out of his pickup. He looked all around the house and couldn't find anything to put gas in except a bedpan. So he put some gas in it. The man walked back down to his truck and started pouring the gas in. Here came this drunk walking down the road, and he stopped and said, "Here, I didn't know that would work, and I've been paying over $2.00 a gallon for gas."

I CANNOT BELIEVE THIS IS HAPPENING

My wife and I were pastoring a small church in Elwood City, PA, which is about 30 miles north of Pittsburgh. We were doing quite well there with some great people. My niece, Mary, and her good friend, Debbie, were called to preach. So I had them come up to preach a revival for us. One night when Debbie got up to preach, she began to talk about what a great man of God I was. She told my people that they had the greatest pastor in the state of Pennsylvania, and the more she talked, the more embarrassed I was getting. So she finally looked at me and said, "Brother Jimmie, what else did you tell me to say?" The crowd just roared with laughter. My wife and I had to go to Pittsburgh for some business, so we took Mary and Debbie with us. We stopped at a big restaurant to get some lunch. The waitress overheard us talking and asked us where we were from. We told her Tennessee. When she came back over to our table, Mary asked her if they had an inside bathroom. The waitress said, "Are you kidding me?" Mary said, "No, I've never seen one before." The waitress said, "Follow me, and I'll take you and show it to you." So she did. When Mary came back out of the enclosure in front of the bathroom doors, she hollered out loud, "Hey, Jimmie & Morine, would you all come and look at this!" That waitress actually believed they had never seen a bathroom before.

AROUND THE ALTAR BENCH

Being a pastor doesn't mean you're not allowed to laugh, and you won't encounter some funny situations. For instance, one night I was praying with a man in the altar, and I noticed after a while that he was not speaking. I got a little closer to him and listened to him, and he was snoring. I woke him up and told him that the church service was almost over, so he went back and sat down. On another occasion, a rather heavy-set lady came up to pray one night, and this bald-headed man came and kneeled right beside her. This lady was really sincere, and she got to sweating. She finally sat up on the altar, and her glasses

were all fogged over. She glanced down and saw that man's bald head and thought it was her knee and jerked her skirt over his knee.

MAN, WHAT A GOOFY GOSPEL SONG

Many years ago, while pastoring at the Dorton Church of God of Prophecy, we were getting ready to start church when this man walked in carrying a flattop guitar. That was enough to make any pastor nervous. I asked my associate pastor, Charley J., if he knew the man, and he told me he had seen him around. I said, "Do you think he wants to sing?" Charley said, "I'd say he does, he's got his guitar with him." But Charley had a slight grin on his face. I thought, "Oh boy." I opened the service, and we had our worship, a few testimonies, and then special music. I introduced this man and told the congregation that we were glad to have him with us, and that he would be singing us a special song. The man started to sing "A LIGHT AT THE RIVER." I stood up to take back over the service, and he turned around and looked at me and said, "Well, I feel led of the Lord to sing one more." I said, "OK," and sat back down. Then the man said, "This song may sound a little humorous, but it's got a good meaning, and the name of it is, 'WHERE'D THE MILK MAN GO?'." I was sitting on the platform behind this man and got to listening to the words of this song. It was telling how the rapture had taken place and about these women, wondering what had happened to their milkman. At the time, we had a church full of young people, including my own kids. They saw me trying to hold my mouth so no one could see me laughing. When they saw me, they lost it, and the whole church saw and heard what was going on and they all started laughing. Well, I never could get things back together, so I just called it a night and dismissed.

A GOOD WELCOME

One night, just before the service, I saw a couple of our young men going into the bathroom right at service time. So, I thought it would

be fun, and I hit the bathroom door with my fist, hollering, "Come out of there!" Well, a man stepped out whom I had never seen before, and he was looking at me strangely. I tried to explain that I was just trying to have a little fun with our boys. He said, "At least I had a good welcome." For some reason, I never saw that man again.

WHERE DID HE GO

One night, a woman woke up from sleep, turned over in bed, and noticed her husband was missing. She lay there for a while, thinking he would be back soon, but he didn't return. She got up and started looking through the house for him but couldn't find him until she checked the basement. Finally, she found him in the corner of the basement, weeping. She asked him what was wrong, and he told her, "Your daddy told me that if I didn't marry you, he'd have me locked up for twenty years." The woman asked, "Well, what are you crying about?" He said, "I'd have gotten out yesterday."

WAIT A MINUTE, DAVE

This story may be a little unbelievable, but it's true. When a person comes from the remote hills and hollers, you don't know how rough their life might have been. My good friend, Dave M., used to walk about a mile for his mom to buy a gallon of milk for a dime. One day, he got to his neighbor's farm and told her his mom had sent him after a gallon of milk. The woman said, "Well, David, I just poured the last gallon I had into the hog trough. It's still warm. If you wait a few minutes, I'll go out there and dip it up for you, and it'll be real close to a gallon."

IS THE COAST CLEAR

One evening, a fellow named Joe S. took a night off from work and was sitting in his recliner, watching "Gunsmoke" when the phone rang. His

wife overheard him say, "Well, how do I know? That's a thousand miles from here." Joe's wife asked, "Who was that?" Joe replied, "It was somebody wanting the Coast Guard." His wife said, "The Coast Guard?" Joe said, "I guess they wanted the Coast Guard. They wanted to know if the coast was clear."

JOE JUST GOT HOME FROM VACATION

When Joe, an eighteen-year-old who was in the third grade, returned home from his vacation, his teacher overheard him telling his friends about the great time he had. She asked him where he had been on vacation, and Joe told her they had gone to Punxsutawney, Pennsylvania. She replied, "Oh, that's where that world-famous groundhog named Phil lives, Joe. Can you spell that for the class?" Joe thought for a moment and then said, "Well, come to think about it, we actually went to New York City."

He went on to explain that he went on a boat ride, and the boat had an accident, leaving him stranded on a beach where everything was dark red. The sky was dark red, the sand was dark red, and even the fruit was dark red. Joe mentioned that he was shocked to see his skin turning dark red, so he cried out, "Oh no, I've been marooned!"

NOW THAT'S A SMART DOG

Marvin couldn't stop bragging to his friend Bruce about how intelligent his bird dog, Bruno, was. So, Bruce decided to join Marvin for a bird hunting expedition. Early in the morning, they set out. Bruno led them through a big field and eventually came upon a large brush pile. Marvin sent Bruno into the brush, and he came out, patting his paw on the ground once. Marvin said to Bruce, "That means there's one bird in that brush pile." Marvin gave Bruno the command, and sure enough, he flushed out one bird from the brush pile.

The same scenario played out at the next brush pile, but this time, it was two birds. They moved on to the next brush pile, and Bruno came out dancing. Marvin exclaimed, "There's a whole bunch of birds in that brush pile." Then he instructed Bruno, "Go get 'em, boy." Bruno went in and flushed out hundreds of birds. When Bruno came out and went completely wild, Marvin declared he'd never hunt another bird again.

ARE THESE DISHES CLEAN

My wife and I went to have Sunday dinner with a very kind man and his wife, and it was incredibly delicious. This lady prepared some of the best-fried chicken you could ever ask for. However, when we sat down at the table, I whispered to my wife that the dishes didn't appear to be very clean. Evidently, a lady named Judy overheard me, and she spoke up, saying, "Those dishes are as clean as soap and water can get them."

We assumed it might be due to the way her dishwasher left them, so we politely decided to go ahead and eat. After a few minutes of conversation around the table, Judy collected all the dishes and carried them out to the back porch. She set them down and then hollered, "Here, Water! Here, Soap! Come and get it, boys!"

WHAT ARE YOU DOING UP THERE

One of the funniest things that ever happened to me occurred in Columbia, South Carolina when my friend Lonnie had to go down there for some business. Lonnie was in desperate need of using the bathroom, and we found ourselves in a very upscale restaurant. However, the restroom required a dime to be inserted in the change slot on the door before it would open. Neither of us had a dime.

So, I clasped my hands together to give Lonnie a boost over the top of the door. When he got on top, he discovered a man inside who looked up at him with a puzzled expression, as if to say, "What are you doing up there?" Startled, Lonnie jumped back down and told me, "There's a man sitting in there. Let's go find some change." And off we went to find a dime.

BEN WAS A GOOD MAN

Joe had a job driving a cab in Crossville, which he absolutely loved. He would arrive early and stay late. One day, Joe picked up a passenger named Bill, who remarked, "You're just like Ben, always right on time." Bill asked, "Is that right?" Joe replied, "Yes, Ben was always punctual, and not only that, he was an excellent dancer. He could follow a recipe, and his cooking turned out perfectly every time. He was incredibly romantic and always made his wife happy. Ben knew how to make friends, and everybody loved him. He was a fantastic musician with great taste in music, entertaining everyone." Bill inquired, "Did you know Ben personally?" Joe responded, "No, but I'm married to his widow."

CLEARANCE AND OLLY

Clearance and Olly lived on opposite sides of the Ober River, way down in Hebbertburg, where the Orbed and Daddy's Creek converged. They couldn't stand each other and would constantly exchange

threats and insults. However, both of them knew they couldn't physically reach each other because of the deep, wide river that separated them.

Sometime later, the state authorities constructed a road and built a bridge down below where these two men lived with their families. One day, Olly's wife suggested, "Now that they've built that bridge down there, why don't you go across it and settle things with Clearance instead of threatening him all the time?" Olly agreed, "I think I will go over there and put an end to this so he'll keep his big mouth shut."

Olly left the house, but he was back within ten minutes. His wife asked, "What's wrong with you? You didn't have enough time to go over there and confront that man. Why are you back so fast?" Olly explained, "Well, when I got to the bridge, there was a sign that said 'CLEARANCE 11 Feet and 2 inches,' so I thought it would be best if I just came back home."

WHO IS HE ANYWAY

Two locals from downtown Crab Orchard went hunting on the mountain near Grassy Cove and stumbled upon a cave. Curious, they decided to explore it. Inside the cave, they discovered a man's lifeless body. Concerned, they contacted the County sheriff to come and identify the man. However, they were unable to do so, prompting the sheriff to decide to send the body to Nashville for forensic experts to determine his identity.

The sheriff instructed two of his deputies to transport the body to Nashville, but they expressed their reluctance, explaining that they had important plans for the weekend and asked if someone else could do it. The sheriff refused their request, insisting they were the ones who had to handle it. One of the deputies humorously remarked, "If we don't know who he is here in Crossville, how in the world are they gonna know who he is in Nashville?"

HOT AND COLD IN BAT TOWN

There was a man named Clyde who was known for telling some of the wildest stories you could ever hear, and he'd spin these tales even if he knew you didn't believe them. Bat Town, Tennessee, is located on the outskirts of the metropolitan area of Crab Orchard and is home to many good-humored people. Clyde once claimed that it got so hot in Bat Town that he saw a robin pulling a worm from his garden using a potholder. He also mentioned seeing a dog chasing a cat, and both were walking. He then went on to say that one day he was plowing his popcorn field, and it got so hot that the popcorn started popping, and his old mule, thinking it was snowing, laid down and froze to death.

JESUS SAID, LO, I AM WITH YOU

Aubry B., a friend from Punkin Center, shared that he was not a fan of flying, and besides, he believed that Jesus said, "Lo, I am with thee," so he preferred to stay on the ground. He humorously pointed out that when you get close to a big airport like Nashville, the first sign you see says "TERMINAL," which seems like the end to him. Aubry shared an amusing experience when he took a flight from Crossville to Hazard, Kentucky on Tarpen Head Airlines. He said it cost an extra $5.00 to ride on the inside. The pilot, he claimed, told the passengers, "Welcome, folks, we should be safe because I just put a rebuilt carburetor on this thing. We'll be flying at an altitude of about 75 to 80 feet at approximately 62 miles per hour. If everything goes well, we should arrive in Hazard in about five hours and forty minutes."

JAMES AND TUCKER HUNTING

Two older men from Creston found a hole in the ground while they were out hunting in the woods. They decided to throw a rock into the hole to see how deep it was but didn't hear it hit the bottom. They tried with a bigger rock, but still no sound of it reaching the bottom.

Determined to find out, they threw a railroad tie into the hole, and suddenly, a black and white goat came racing past them at an incredible speed. A man then approached them and inquired if they had seen a black and white goat, explaining that he had tied it to the railroad tie. James replied, "Yes, we saw him. He jumped into that hole over there."

GOING THROUGH

One morning, a farmer went to his henhouse to gather eggs. When he reached under his chicken, he didn't find an egg but discovered a nickel instead. The next morning, the same thing happened, but this time he found a dime. On the third morning, he reached under his hen again, and there was no egg, but there was a quarter. The farmer was puzzled and called the veterinarian, explaining the situation. The veterinarian replied, "There's nothing wrong with your hen; she's just going through the change."

I'LL NEVER EAT ANOTHER ONE

A man from Crab Orchard had never ventured beyond Cumberland County, but he decided to take a train to Asheville, NC. While on the train, the conductor was distributing fruit, and Joe chose a banana, as he had never tried one before. Just as he took a bite of the banana, the train entered a tunnel, plunging everything into pitch darkness. The conductor asked Joe if he wanted another banana, and Joe replied, "No, I took one bite of that thing, and I went blind as a bat."

WHAT FISH ARE YE TALKING ABOUT

George W. was finishing up his day of fishing in Daddy's Creek, which was at his favorite spot out past Pea Ridge. As he was preparing to get into his pickup truck, a game warden pulled up and discovered George with two large coolers filled to the brim with fish. The game warden requested, "I need to see your fishing license." George, however, confidently responded, "I don't need a license for these; they're pet fish."

Perplexed, the game warden inquired, "What do you mean, they're pet fish?" George explained, "Every night, I take these fish down to the creek, let them swim around for a while, and then I call them, and they all swim right back into my coolers." Skeptical, the game warden challenged George, saying, "I'll have to see that to believe it."

George proceeded to take the coolers full of fish down to the creek's bank and emptied them into the water. He and the game warden stood there for a few minutes, and then the game warden asked, "Well, when are you going to call them back?" George innocently replied, "Call what back?" The game warden, now puzzled, said, "The fish!" George, with a mischievous grin, responded, "What fish?"

A SENIOR MOMENT

One day, while I was going to lunch in downtown Crossville, I had some time to spare. I noticed an elderly gentleman sitting on a park bench in Courthouse Square, so I decided to sit down next to him. We struck up a conversation, and he began to tell me about his wonderful wife. He mentioned how she always cooked him a delicious breakfast, prepared the best lunches, cleaned the house, and watched football games with him. He also shared that when his back hurt, she would lovingly massage it, and she brewed the finest coffee he had ever tasted.

As we talked, I noticed tears welling up in his eyes, so I asked, "If she brings you so much happiness, why are you crying?" The elderly man replied with a hint of sadness, "I can't remember where I live."

WE COME ABOARD

Jack B. shared an amusing story about catching a flight from an Army base in Denton, Texas, to Beaumont, Texas on Boweavle Airlines. During the flight, the Flight Attendant made a series of humorous announcements. She began by saying, "Welcome to Boweavle Airlines. We are pleased to say that we have some of the best pilots in the industry, but unfortunately, none of them are on this flight." She continued, "We also have some of the safest planes, but the one you're on is old and worn out, although it still runs pretty well."

The Flight Attendant provided instructions on how to fasten the seatbelt, adding a humorous note: "It works like any other seatbelt, and if you don't know how to operate one, you probably shouldn't be out in public unsupervised." She also addressed the oxygen masks, saying, "In the event of a sudden loss of cabin pressure, oxygen masks will descend from the ceiling. So stop screaming and put the mask over your face. If you are traveling with a small child, secure your mask before assisting theirs. And if you are traveling with two small children, you need to decide which one you love the most."

Lastly, she mentioned, "After the plane lands, be sure to gather your belongings, because anything left behind will be distributed evenly among the flight attendants." She concluded by thanking the passengers for flying with Boweavle Airlines and hoped they enjoyed giving the airline their business as much as they enjoyed taking passengers for a ride.

OLE BLUE BONNET

Rondal B. shared a humorous tale about his neighbor Fran, who churned butter and buttermilk while chewing tobacco. When she spat tobacco juice while churning, the wind would blow it onto the butter,

leaving it spotted with tobacco stains. Rondal and his family received some of this butter, but he would throw it out for his Redbone hound dogs. One day, his mama's hound had a puppy, and he named it Blue Spotted Bonnet.

LET'S GO TO WATTS BARR

James and Luther, who lived on Crab Orchard Boulevard in Crab Orchard, loved fishing, and one day they decided to head to Watts Bar Lake below Spring City to see how the Crappie were biting. Before their fishing trip, they stopped at Leon's place to get some Tennessee scorch (moonshine) because they believed it would make the crappie bite better when applied to their bait. By the time they rented a boat and got on the lake, they were a bit tipsy, but they managed to find a good fishing spot. The crappie began biting their lures like crazy, and they quickly caught more than their limit.

Wanting to mark the spot for future trips, they scratched a big mark on the bottom of the boat by their anchor. However, when they were nearly back at the boat dock, Luther suddenly exclaimed, "Oh no, what are we going to do now?" James asked, "What's the matter?" Luther replied, "How do we know we'll even be able to rent the same boat again?" James, taken aback, admitted, "I never thought about that."

YOU CAN SELL ANYTHING

Albert and Cletus S. made a decent living by buying items, fixing them up, and selling them. They once painted a 1962 Willis with glossy black paint using a paintbrush, making it look sharp from a distance. They sold it for $250. They also had a 1959 Chevy Biscayne for sale, and they placed a sign in their front yard that read, "1959 Chevy Biscayne For Sale $325.00 or $275.00." When someone bought it, they had the option to choose which price to pay.

In a humorous twist, Albert and Cletus picked a whole pickup load of cockleburs and drove up north to a farmer's market outside of Chicago. They sold the entire load as "Porcupine Eggs" and made $20,140.00.

THAT WILL NOT WORK LIKE THAT

One day, my buddy Ted R. and I were sitting on liar's bench at the Cumberland County courthouse when we saw a dignified-looking lady walk by, dressed quite elegantly. What caught our attention was the gold nose ring attached to her right nostril and a little gold chain connecting it to her right earlobe. Ted commented, "My goodness, she had better be careful because if she jerks her head around, she will either tear the side of her nose out or rip her earlobe out." I responded, "No, she wouldn't, because the nose and ear would both move at the same time." Ted pondered this and asked me, "I don't know how you figure that."

Joe from Raven Croft WENT TO THE SUPER BOWL

Joe S. from Raven Croft was a passionate football fan, so he decided to attend the Super Bowl held at the Pontiac Silverdome when Pittsburgh was playing the Seattle Seahawks. Upon entering the stadium, an usher directed him to a seat at the very top of the bleachers, making the players look like tiny ants from that vantage point. Determined to get a closer view, Joe spotted an empty seat right next to the field and made his way down to it.

He asked the man seated next to the vacant chair if it was taken, and the man kindly told him it wasn't and that he could sit there. Joe was surprised and commented, "I can't imagine anyone having a Super Bowl ticket and not using it." The man responded, "Well, normally my wife would have been with me, but she passed away." Joe expressed his condolences and then inquired, "Couldn't you have invited your brother or a friend to come with you?" The man replied, "I could have, but they're all at the funeral."

SOME STRANGE, BUT TRUE HAPPENINGS

My parents lived on Jones Farm for many years, and my dad worked there, smoking hundreds of country hams. This place was located on Highway 70 East, where the bypass now runs. One day, my brother Danny and I were up on Mrs. Jones' farm when we noticed a very old International pickup truck sitting in a field. We asked Mrs. Jones if she wanted to sell it, and she told us it hadn't been started in about 17 years but that we could have it.

We used a tractor to pull it down and push it into her shed, and then we began working on it to see if we could get it started. We found the distributor's points were rusted in two, so we found an old set in my junk and managed to make them open and shut properly. After a few days of tinkering with the old truck, ensuring it had oil and water, we decided to try starting it. To our surprise, the old truck started right up, although it initially emitted a lot of smoke, making it look like the entire countryside was on fire. However, after a few minutes, it cleared up and ran quite well.

We continued to work on it, sanding it down to make it look present-able, and my brother Danny and brother-in-law Ronnie eventually traded it for a 1957 Chevy, a nice car. Sometime later, my wife and I moved to Fort Knox, Kentucky, and I left a 1962 Dodge Lancer at my parents' house, on which I still owed CIT $460.00.

Upon returning home one weekend, we noticed that the car was missing. After inquiring, my mom told us that a wrecker had come and pulled it away. I insisted that wrecker trucks don't just take vehicles without authorization. Eventually, my mom reluctantly admitted that Danny had sold it. When I asked how much he got for it, she told me $15.00. To my surprise, my brother Danny and brother-in-law Ronnie had stolen my car and sold it to Hill's Junk Yard. Not only that, they had stolen my sister's 1958 Studebaker on the same day and sold

it for $15.00 as well. When Danny returned home, he was grinning, and I asked where my car was. He casually responded, "Oh, it's out on the road somewhere." I then inquired about the money, and he told me they had used it to buy thirty quarts of Blue Ribbon beer. So, I got swindled!

GET ME OUTTA HERE

Many years ago, Bishop Omer C. Lawson was the States Overseer for The Church of God of Prophecy in Michigan. He asked my wife and me to move to Grand Rapids and pastor a church there, and we agreed. After settling in, a young man offered to show me around the city to help me get acclimated.

As we began driving, I was taken aback by his reckless driving, which resembled that of a maniac. The roads were covered with snow piled up to about twenty feet high due to recent scraping. We were traveling on 18th Street, the second busiest street in Michigan after Woodward Avenue in Detroit, going about 55 mph in a 35 mph zone. I thought to myself that I would never get back in the car with this guy once I got home.

As we sped down this busy street, he turned to me and said, "I don't have any brakes. What should I do?" At the bottom of a long hill, we were rapidly approaching a red light with many cars stopped. I knew we would rear-end one of them if we didn't act fast, so I spotted a huge snowbank by a service station and yelled, "Drive into that snowbank!" We went through the gas pumps and ended up buried in the snowbank.

We eventually managed to get out safely and make it back home, but I kept my promise to myself and never got back in a car with that boy again. This is a true story.

HE AINT NO DUMMY

This group of teenage boys was hanging around a video arcade when one of them, Jake, noticed Ben arriving from Crab Orchard. Jake turned to his friends and said, "There's that kid from Crab Orchard; he's not very bright. Come over here, and I'll show you how gullible he is." Jake then took out a dollar bill and held it in one hand, and in the other hand, he held two quarters. He called Ben over and said, "Hey Ben, come here and choose which you think is worth more money." To everyone's amusement, Ben took the two quarters, and they all laughed.

The owner of the arcade witnessed the incident and followed Ben outside. He said to Ben, "Ben, I saw what happened in there, and I know you're smarter than that. Why do you let Jake treat you that way?" Ben replied, "Oh, Jake does that all the time. The day I take the dollar, the game is over."

TALK ABOUT SOUTHERN HOSPITALITY

A few years ago, my friend Luther was serving as a pastor in Sunbright, Tennessee. He and another church member, Jay, set out to visit a family living in the hills around the town. Although they had the names of the couple they were supposed to visit and directions to their home, they soon found themselves unsure if they were at the right place.

Luther and Jay approached a house where they spotted an older man sitting on the front porch. They explained the purpose of their visit to the man, even though they had forgotten the names of the couple they were looking for. The gracious old man invited them to have a seat on the porch and chatted with them. After a while, he mentioned that his wife was preparing supper and invited the visitors to stay. Luther and Jay agreed, thinking it would be a good opportunity to build a connection and possibly convince the couple to attend church.

They enjoyed a meal and continued their conversation. Eventually, they realized it was time to leave, so they bid the elderly couple farewell. As they got back in their car, Jay commented, "I think that couple is great, and I bet they'll show up at church on Sunday." Luther, however, had a realization and said, "Yes, but I don't think they were the couple we were supposed to visit." This story reflects the hospitality and friendliness found in the hills of Tennessee.

DAGUMMIT I'M OUT OF HERE

In another humorous anecdote, an evangelist named Ron shared a funny story during a sermon at the church. He recounted a bet he had made with a man at the Dairy Queen. Ron bet the man $5 that he couldn't recite the Lord's Prayer, and the man accepted the challenge.

He began, "Now I lay me down to sleep, I pray the Lord my soul to keep. If I should die before I wake, I pray the Lord my soul to take."

After hearing this, Ron admitted defeat and handed the man his $5, saying, "Well, here's your five dollars. I didn't think you knew it." However, one member of the congregation didn't find the story amusing. He jumped up, exclaimed, "Dadgummit, I'm out of here," and hastily left the church. True story, but not everyone appreciates humor in the same way.

GET ARE DONE

In this humorous story, Goofus decided to play a prank on his neighbor, Glen, by falsely reporting that Glen had hidden marijuana in a truckload of unsplit logs. Goofus called the Cumberland County Sheriff's Department to report this, and two deputies came to investigate. They spent time splitting the entire pile of logs, searching for the alleged hidden drugs. After their thorough search, they couldn't find any marijuana and left, realizing they had been tricked.

Glen received a call from Goofus after the deputies had left, and Goofus asked, "Hey, old buddy boy, did you get your wood all split up?" This story highlights the light-hearted and often playful nature of hillbilly humor.

HILLBILLY'S ARE A DIFFERENT SORT

The second part of the text describes the unique humor of hillbillies. It mentions that they are different from others and love to engage in conversation and share jokes and riddles. The text provides a couple of hillbilly-style jokes, such as the one about the monkey and the snail, which are characterized by their simple and quirky humor.

The final part of the story shares a tale about an inventive hillbilly who tried to hide a half pint of moonshine by tying it around his ankle and walking home. However, he ended up dropping and breaking the bottle when he attempted to take a sip. This anecdote showcases the resourcefulness and creativity of hillbillies in everyday situations, even when it comes to hiding their moonshine.

PASTORS DO HAVE A SENSE OF HUMOR.

I have served God for fifty years, and my wife Morine and I have pastored for forty-four of those years, but I've never lost my sense of humor. I do not believe there is anything wrong with good, clean humor, and I don't believe we have to be baptized in pickle juice. None of us have to be sad and depressed, and we won't be if we have a good relationship with Jesus Christ. I have a good friend who pastored for many years in Cleveland, Tennessee, and is currently serving as Regional Overseer over the Northwest Region of Pennsylvania, and boy, does he have a sense of humor. He was preaching a revival for me at this church, so we went to this big store like Wal-Mart, and we were in the paint department, and in front of some other people looking, he held up a can of mineral spirits and said to me, "This stuff makes the best mouthwash," so this guy that overheard him said, "That stuff will kill you, want it." We got out to the front of the store, so Brother Ron hopped up on one of those little child riding horses, so before he got off, I dropped a quarter in it, and it took off. Ron started hollering, "Whoa, whoa, whoa," so here came two older ladies out of the store, and they looked at Ron on that horse, and both of them gave him the meanest look you've ever seen. We went into Hardee's to get us some lunch, and there were a couple of long lines in there, and there were two artificial rubber trees in the corners, so he pointed out to me and all the others in line that they made tired and floor mats and so on out of those trees, so one ale boy who looked like a real redneck said, "Why them things ain't ever real, are they"? Another pastor friend of mine named Don P. and myself, along with our wives and kids, were at Gatorland together in Orlando, so we were watching these huge alligators jump up out of this pool and get chickens a man was holding on a stick. Don said in front of all the folks watching, "That ain't real," a man said, "What do you mean, it ain't real"? Don said, "If you look real close, you can see where the battery pack is located in them." The man said, "You're Crazy." He did that same thing while we were standing by the

Ostriches, and the big bird reached out across the fence and pecked him.

FUNNY SITUATIONS

Generally speaking, pastors will sit through many surgeries in their lifetime of ministry, and for the most part, they are happy to be there to try to comfort the families. One time this old boy named Milford C. was up at Cumberland Medical Center with his wife who was having surgery, so I went up to be with him. He was a very funny man and a joy to be around, so we sat there and talked while his wife was being operated on. As I recall, when the surgery was over, a nurse came and took us back to the consultation room, so after a little while, the doctor who did the surgery came in. He proceeded to tell Milford what all he had done and that it was very successful, so finally he looked at Milford and asked him if he had any questions, so Milford said, "Yeah, I've got one." The doctor said, "Alright, go ahead," so Milford said, "Will she still be able to plow"? I was embarrassed, and the doctor didn't see that much humor in it. At another time at the same hospital, I sat with a man named Larry while they were doing this dye test on her to see what was wrong with her heart, so after a while, the doctor met us in the consultation room to explain what he had found. I believe the doctor was from India, so he had a foreign accent and was super nice, so he explained to Larry everything he did and finally told Larry that his wife had a leaky heart valve. Then he asked Larry, "Do you have any questions"? Larry said, "Yes, I do, Doc, do you have a can of Stop Leak"? This Dr. looked kinda stunned at Larry and said, "No, no, no, we must fix it." When the doctor left, I said to Larry, "I can't believe you said that," and Larry said, "Ah, she'll be alright."

A FEW CLOSING NOTES

As stated earlier, I was born on the LeVern Wheeler farm in Crab Orchard, Tennessee, right off of Bat Town Road and Halley's Grove Lane, about a quarter of a mile from where Interstate forty runs through now. I was raised around the Crab Orchard and Crossville area until I joined the US Army in 1965 and was stationed at Fort Benning, Georgia, and Mannheim, Germany, then moved back to Crossville in July 1965 after my Army term was over. My wife Morine and I got married on June 6, 1964, in Crossville, and we both worked around at different areas and jobs in Tennessee until 1972, but we never could really do any good, so we moved to Pontiac, Michigan, on January 13, 1972, and I got a pretty good job in Detroit making decent money. Later on, I got a job at Pontiac Motors on the assembly line making 1973 Pontiacs. On February 13th, 1972, we attended a revival service at a small church in the town of Utica, Michigan, and we both went to the altar and gave our hearts to the Lord. In May of 1974, I was called to preach and started preaching revivals all across the state of Michigan and in Ohio. I even came down to Tennessee to preach at a few churches. Roy and Faye Meadows and their family moved up to Michigan, and we sang together, doing many revivals together across the state.

While attending the Pontiac Church of God of Prophecy, Orner C. Lawson from Crossville was appointed to be State Overseer of the Church of God of Prophecy in Michigan. He asked my wife and me to pastor the local church in Grand Rapids. We were there for a couple of years, and then we were asked to come to Pennsylvania to pastor. So, we moved to Pennsylvania in July of 1977 and started pastoring in Elwood City. We stayed there for two years, and then we wanted to come home to Tennessee, but the overseer of Pennsylvania asked us to stay. After much prayer, we decided to stay. At the Pennsylvania State Convention, we were appointed to a small church known as the "Church in the Wilderness." It was in a little village called Fertigs,

which was a very good community. As it turned out, it was a place where we had the greatest years in our ministry.

The local church folks had an old, run-down building which they had been in for many years, and it was actually being held together with sucker rods, which are steel pipes that go down into oil wells. The overseer, Bishop Howard Hunt, had told me at the State Convention, "Brother Turner, those folks need a new church up there." So, I began to look into building a new sanctuary. Deacon Jim King and I started going to different banks to try to borrow money, but not one would even talk to us. We were stuck without an answer, or so it seemed.

One morning, during this, a little lady who was our piano player spoke up and said, "Brother Turner, can I say something?" I told her she sure could, and she said, "I think it's about time for all of us to get rid of all these white elephants we've got in our attics." Being from Crab Orchard, I thought a white elephant was a white porcelain elephant, and I was thinking, "You ain't going to get any money out of those things." Boy, was I wrong! Those folks began bringing me all kinds of gold jewelry, gold coins, and all kinds of stuff with a lot of money, and right away, we had about $15,000.00. We built a new parsonage first and paid it off in two years.

Then we went to the bank and tried to borrow the money to build the sanctuary, but it was the same story. My treasurer went to many different banks trying to borrow money to build the church, but nobody would even talk to us. I had reached the end of my rope and sat down in the woods on a log, and cried out to God for help. I prayed and prayed for many days and weeks and was ready to give up pastoring forever. Then one day, a knock came on the parsonage door, and the man said, "I'm here to talk to you about leasing your land to put down a test hole to see if you all might have oil." To make a long story short, we had to research everything to see if our church owned the mineral rights, and we found out we did. So, the oil drilling company came in and drilled five oil wells on our property, and our small local church

started receiving royalty checks from Quaker State Refinery in Oil City every month.

We were able to build our sanctuary, and God filled it with people. The tiny church in the wilderness turned into the largest Church of God of Prophecy in the state of Pennsylvania.

JESUS IS ALL THAT WE NEED

One. I appreciate my family, our kids, and our grandkids, and Sis. Turner and I love them all very much. We appreciate our church family and all you do for us.

Two. I appreciate all the great assemblies, conventions, Bible schools, retreats, youth camps, overseers, great sermons, and great encouragements I've personally received.

Three. And Morine and I appreciate all the great love offerings and tithes we have received over the years, but none of the great blessings we have received could save us.

1 Corinthians 2:1-2: "And I, brethren, when I came to you, came not with excellency of speech or of wisdom, declaring unto you the testimony of God. For I am determined not to know anything among you, save Jesus Christ and Him crucified."

One. One: Paul was plainspoken, and here he told the Corinthians that he did not come to them with excellency of speech to declare the testimony of God or to talk about Jesus.

Two. Then he said he was determined not to know anything among them except Jesus Christ and Him crucified, meaning that Jesus Christ is the only way to salvation.

Three. There is no other act or work in the history of the world that can lead us to heaven except the work Jesus did at Calvary by making the ultimate supreme sacrifice.

Four. Buddha could not do it, and the Pope could not do it. Neither can any great prophet or preacher on the face of the earth, only Jesus can.

Acts 4:12: "Neither is there salvation in any other. For there is none other name under heaven given among men, whereby we must be saved."

One. So, there is no other way to God except through Jesus! One: Nobody on earth goes to heaven who doesn't know Jesus. All will be lost forever if they don't have a personal relationship with Him, no matter how hard they try to live a perfect life.

Two. Now that we know how much we need Him, we need to know who He is. So, let's focus on who He is during this time of earth-shaking events and see if you'll hold on to Him.

Three. I don't know if this is true, but it was said by some people who are supposed to know that Japan was moved six feet closer to the U.S., and the earth was moved six feet.

John 1:1: "In the beginning was the Word, and the Word was with God, and the Word was God."

One. Jesus Christ was the Word, still is the Word, and will always be the Word. He was there when God said, "Let us make man in our image and in our likeness."

Two. He was and still is the only begotten Son of the Father, without beginning and without ending. He was with God and is still sitting at the right hand of God in heaven.

John 1:2: "The same was in the beginning with God."

One. This is talking about the beginning of the world, and in verse three, it states, "All things were made by Him, and without Him, not anything was made that was made."

Two. If this is correct, He is the Creator, and He made all the heavenly or celestial bodies, including the earth, sun, moon, stars, the billions of stars in the Milky Way, and named them.

Three. He made the woman He was born out of, the world He was born into, the swaddle blanket He was wrapped in, the manger they laid Him in, and the tree He died on.

Four. He made you and me, and we were born to serve Him.

Five. There is no other name given among men down through the history of time, whereby men could be saved, and there have been many great names we could look at.

Six. Names like Abraham, Isaac, Jacob, Sarah, Moses, Joshua, Samuel, Ruth, David, Solomon, Esther, Elijah, Deborah, Ezekiel, and Daniel. As great as they were, none of them could save a soul.

Seven. No set of numbers, no set of stars, no set of years, no set of sequences, no knowledge of prophecy, no idea, no opinion, no formula, no horoscope. Only Jesus can satisfy your soul.

Philippians 3:8: "Yea doubtless, and I count all things but loss for the excellency of the knowledge of Christ Jesus, my Lord. For whom I have suffered the loss of all things and do count them but dung, that I might win Christ."

One. Paul here tells us what he was ambitious about, and it certainly was not things. What he reached for was Christ and His knowledge. He wanted to know Him more and more.

Two.	He wanted a believing, experimental acquaintance with Christ as Lord, not a notional or speculative sideshow, not an on-again, off-again, looking-back, old-way experience.
Three.	Paul said, just to know Him, I have suffered the loss of all things, and in fact, count them as dung, or that is, things of this world mean absolutely nothing to me.
Four.	As far as winning Christ goes, Paul was saying, I am willing to lose all to find Him, or that is, find favor with Him because more than anything else, He's all I need.

1 John 5:12: "He that hath the Son hath life, and he that hath not the Son hath not life."

One.	This is very simply saying, if you have Jesus in your heart, you will live forever. If you don't, you'll go to hell.
Two.	To put everything in its proper perspective, I've got to say, Christ means the Anointed One. He is The Son of God and He was sent from God to be the Savior of the world.

Hebrews 1:2: "By whom also He made the world."

One.	I don't know if this is a misprint or not in my Bible, but if it's not, and if it's in your Bible too, or your version too, then it means He made other worlds besides the one we are in.

John 1:14: "And the Word was made flesh and dwelt among us, and we beheld His glory, the glory of the only begotten of the Father, full of grace and truth."

One.	John was saying that the Word of God, Jesus Christ, came down to Earth, was conceived in Mary by the Holy Spirit, and was born of a virgin woman. He lived among us.

Two. John said, we actually walked with Him, and we beheld His glory, and it was the Glory of the only begotten Son of the Father, full of grace and truth.

Hebrews 1:10: "And, Thou Lord, in the beginning hast laid the foundations of the earth, and the heavens are the works of thine hands."

One. So, Jesus Christ, The Anointed One, The Anointed Son, The Almighty God, has laid the foundation of the earth on a solid foundation.

Made in United States
North Haven, CT
12 February 2024

48686932R00085